SECRET
NORTH SHIELDS
& TYNEMOUTH

David Scholey

AMBERLEY

First published 2021

Amberley Publishing
The Hill, Stroud
Gloucestershire, GL5 4EP

www.amberley-books.com

Copyright © David Scholey, 2021

The right of David Scholey to be identified as the
Author of this work has been asserted in accordance
with the Copyrights, Designs and Patents Act 1988.

ISBN 978 1 3981 0584 3 (print)
ISBN 978 1 3981 0585 0 (ebook)

British Library Cataloguing in Publication Data.
A catalogue record for this book is available from the
British Library.

Origination by Amberley Publishing.
Printed in Great Britain.

Contents

1. History

Roman Times

In AD 117 a troop of Roman soldiers tramped over moorland and through the forests of north-east England. Their destination was a remote rocky headland called Benbalcrag overlooking the North Sea and the harbour of the River Tyne, which they called the Tunne. Their purpose was to watch for potential invasion from the north, east or south.

172 years had passed since Caesar had first landed on what until then had been largely regarded as a land of myth occupied by monsters. Caesar quickly installed a friendly local king in an area we now call Essex and Suffolk, staying for the winter and then departing. Subsequent incursions had gradually imposed Roman domination and, after a brief invasion of Scotland, the Roman Empire had now settled its northern frontier on a line from the Solway Firth to Segedenum, around 3 miles inland from the rocky headland that the troop now march towards.

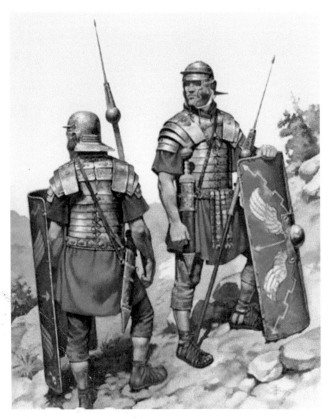

Roman soldiers.

Five more years would pass before the building began of the famous Hadrian's Wall, which defends the land from the ferocious Picts to the north, while the Roman soldiers still had to contend with occasional rebellious factions among the indigenous people of England.

> DID YOU KNOW?
> By the end of AD 117 the Romans had built a lighthouse here, one of the first two in England.

Christianity would not take a hold in England for another 400 years; indeed, it would be an illegal religion in the Roman Empire for 200 years. The Roman troops are most likely to have worshipped Mithras, the mysterious and secretive religion, the followers often worshipping in caves or beneath ground. Benbalcrag had ample caves.

Benbalcrag would later become the familiar headland hosting the castle and priory of Tynemouth so it is fascinating to think of it as a place of both worship and defence long before the days of Christianity.

Mithras.

Early Christianity

By the end of the fourth century the Romans had all but gone and in AD 616 Edwin became king of a united Northumbria. Previously there had been two kingdoms in Northumbria: Bernicia to the north of the River Tyne and Deira from the Tyne to the Humber. Partly by battle and partly by a strategic marriage to the daughter of the King of Kent, Edwin sought to rule all of England. The King of Kent and his daughter were both Christian and within a year of the marriage Edwin too had converted to

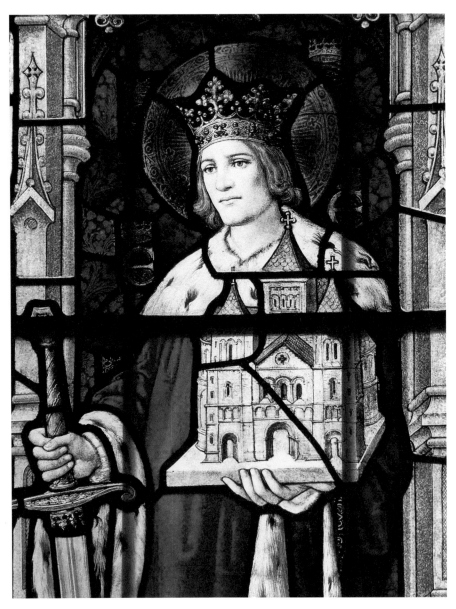

King Edwin. (Courtesy of St Mary's, Sledmere)

Christianity. As a token of his conversion he built a wooden chapel on Benbalcrag. That church was the forerunner to the priory, the ruins of which still attract thousands of visitors each year.

Edwin died in battle in 633 having failed to bring all of England under his control. On his death Bernicia and Deira again became two kingdoms but a few years later Oswald became king of a once again united Northumbria. After death Oswald became immortalised as St Oswald.

On Oswald's death in 642 the kingdom was yet again divided. His brother Oswy (sometimes spelt Oswiu) controlled Bernica while Oswin, a cousin of King Edwin, ruled Deria. To complicate things further Oswy married King Edwin's daughter.

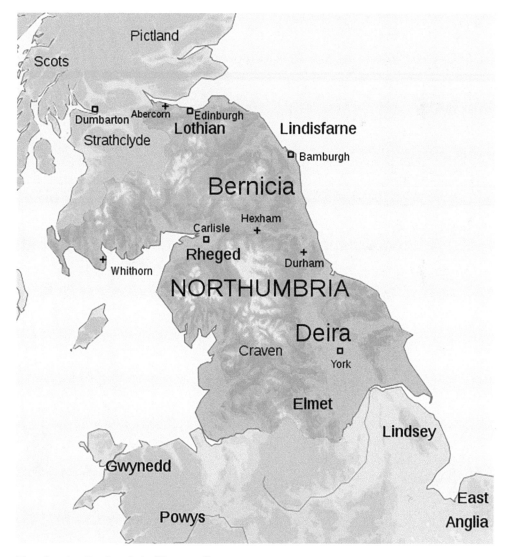

Map showing Northumbria. (Hogweard)

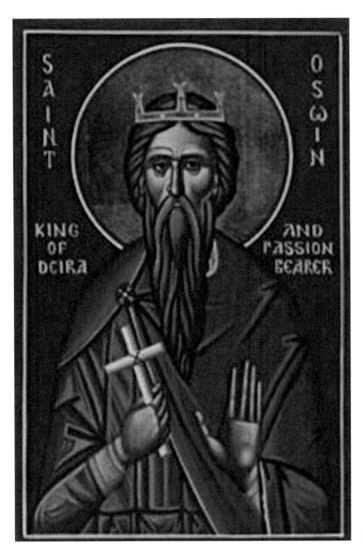

King and St Oswin.

In 651 Oswy summoned a large army to battle with Oswin. Oswin realised that he was vastly outnumbered and, wanting to avoid unnecessary bloodshed, dismissed his own troops and sought refuge with a friend, Hunwald, at Gilling in North Yorkshire. Hunwin, however, betrayed him and Oswin was killed.

DID YOU KNOW?
Oswin's remains were buried at Benbalcrag and Oswy's wife, who had been related to Oswin, insisted that Oswy build a monastery at Gilling in penance for the crime of killing Oswin.

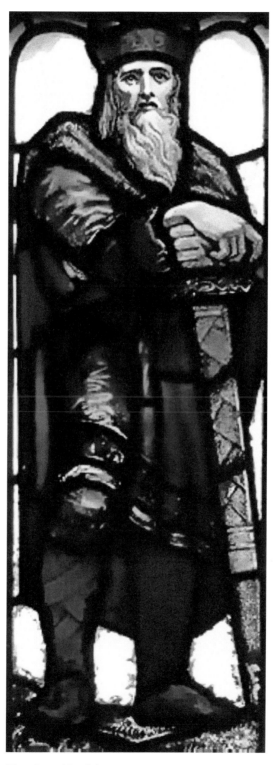

King Oswy (Oswiu).

In 789 Osred II succeeded his cousin but was king for only one year, as Aethelred, the son of a former king, deposed him in 790. Osred was exiled, possibly to the Isle of Man. He returned from exile in 792 but was apprehended and slain in the early autumn of that year. His body too was buried at Benbalcrag, making him the second king to be buried there.

1066 Onwards

After the Battle of Hastings, England fell under the rule of King William I, at least officially. Evidence suggests, however, that Northumbria continued to rebel against the Norman invaders until close to the end of the eleventh century and by then the old wooden Saxon church on Benbalcrag, built by King Edwin, had been destroyed. A Benedictine cell of St Albans was established at Tynemouth and a monastery and associated church was required.

DID YOU KNOW?
A legend exists that a monk from the priory travelled to the Deleval estate demanding alms and refreshments, which he was given, but he was annoyed that he was not offered meat from a roasted pig. He stole a section and lord Deleval chased after him and thrashed him quite severely. The monk later died and Deleval was obliged to pay penance. At the site of the attack stood a stone with the words 'O horrid dede, to kill a man for a pigge's hede'. The stone now stands in Tynemouth Priory grounds.

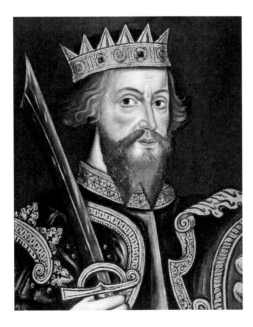

William the Conqueror.

Building of a new church began in 1090 but was delayed due to ongoing conflicts, one of which was the Battle of Alnwick Castle in 1093, which resulted in the death of Malcolm III of Scotland. He too was buried at Benbalcrag, bringing the total of kings buried there to three. This is why when the Borough Council of Tynemouth came into existence the coat of arms contained three crowns. His body was subsequently removed to Dunfermline Abbey but Benbalcrag had provided his first burial ground.

In 1100 the new church, named the Church of Our Lady and St Oswin, was completed and Henry l granted the monks the right to fisheries and wrecks in the Tyne. At around this point in time the combined monastery and church became known as 'The Priory' and the prior held considerable influence over wide areas of the north-east. Areas as far afield as Warkworth and Haltwhistle came under the control or influence of the prior – even parts of County Durham came under his sphere.

Henry II had been particularly generous towards Tynemouth Priory not only in granting it the various estates but also acting as a peacemaker between the Bishop of Durham and the priory when the bishop tried to seize ownership. This support was confirmed by Richard l, often known as Richard the Lionheart, and again in 1204 by King John. King Richard had also been especially generous by stating that he had granted the priory 'all liberties and free powers which the royal power can confer on any church'. In 1205 King John excused the priory from any tax on corn grown within its properties.

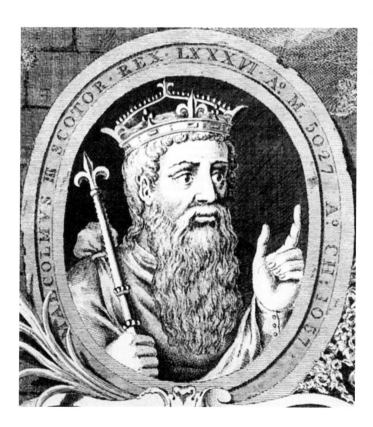

King Malcolm III
of Scotland.

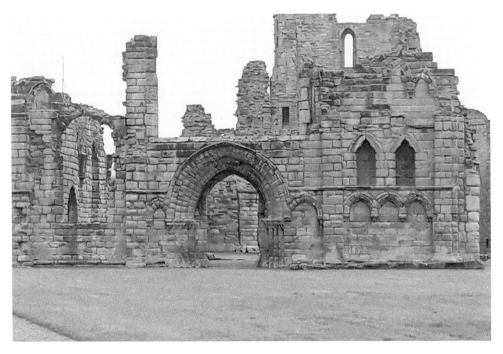

Tynemouth Priory.

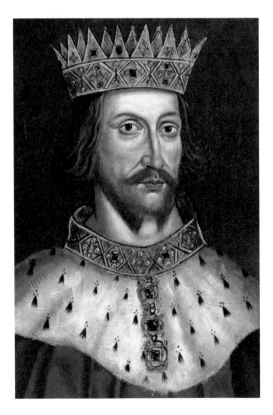

King Henry II. (Courtesy of the National
Portrait Gallery)

King Richard I.

King John.

One place that was less than happy with the prior of Tynemouth was the neighbouring Newcastle upon Tyne and in 1225 the prior set in motion an action that was to have a knock-on effect over the next 600 years. Germanus was the prior at the time. He arranged to drain an area of marshy ground beside the Pow Burn inlet from the Tyne, which lies roughly at the foot of Tanner Bank. He then had built seven shields, which were small thatched huts, and a small quay for each. These were given to fishermen and in return they agreed to provide fish for the monastery.

In itself, this probably would not have unduly concerned the mayor and burgesses of Newcastle, but the tiny hamlet soon attracted other interested parties. Another twenty houses were built nearby followed by a range of commercial activities, bakeries and small brewers, who set up business, and the fishing expanded as far afield as Iceland, resulting in large stocks to be disposed of. Mining began and trade started to flourish from the tiny fledgling port.

Newcastle upon Tyne, based 8 miles along the winding River Tyne, believed that they had the right to benefit from all trade along the Tyne from Ryton to the North Sea, so it quickly became infuriated that North Shields existed without paying the taxes that they claimed were due to the burgesses.

In 1267 what was described as an armed rabble arrived from Newcastle, attacked the monks at the priory, set fire to the mills and houses and seized a ship laden with coal. The prior commenced a legal action and Newcastle promised not to repeat the action. What Newcastle did do in 1275 was petition King Edward I stating that the reduction of taxes collected for the king could be attributed to the existence of North Shields and stated that the prior had 'raised towns where no towns ought to be other than huts for sheltering fishermen'. No decision was made on the petition until 1291 and by that time North Shields was functioning as a port with over 100 houses. The problem was that while the prior had secured charters from various kings prior to and including King John, Newcastle had also secured a charter from King John that conflicted with the rights already granted to the priory.

The decision was that ships could no longer unload or take in cargoes at North Shields nor sell their merchandise there. Nothing could be sold to merchants and any wharves above the high-water mark must be removed. The right to shipwrecks was also removed. This new ruling benefited Newcastle and the king.

DID YOU KNOW?
In 1545 Henry VIII built a fort around 200 yards south of the priory. It was intended to defend his fleet as he planned an invasion of Scotland. He manned it with Spanish mercenaries and to this day the area on which it stood is known as the Spanish Battery.

The situation from North Shields perspective was disastrous. The mine, which had opened just to the west, had previously needed to transport the coal a few hundred yards

to the river's edge but now had to transport their coal 8 miles to Newcastle only for it to be placed aboard a ship there, which would then sail within sight of the mine entrance from which it had been extracted. It had been far more convenient for traders to land in North Shields within sight of the open sea than navigate the further 8 miles along the twists and turns and hazards of the River Tyne to reach Newcastle.

House were abandoned and the bakeries closed. It appeared that North Shields short existence was already at an end. A glimmer of hope came in 1303 when King Edward l granted it the right to hold a fifteen-day fair but the following year Newcastle successfully petitioned to have that right revoked.

Slowly the defiance of North Shields resurrected itself and by the end of the fourteenth century it was once again in business with more land being reclaimed from the sea and over 200 houses had appeared along with shops, butchers' stalls, inns, stables, wine taverns and of course the fish houses. The prior at the time opened bakeries, relying on the one remaining right granted by King John in 1205 excluding the priory from taxation on corn. The prior had once again claimed his right to salvage shipwrecks.

By 1433 the monks had a healthy trade in fish, coal and salt. King Henry VI was more generous than Edward l had been. A tussle began over the next few years with Newcastle,

Course of the Tyne. (Courtesy of the British Library)

King Henry VI.
(Courtesy of the
National Portrait
Gallery)

with rights being rescinded and then granted again only to be rescinded again according to which king was in power and how strong the case presented appeared to be.

Things came to a head in 1510 when a large group from Newcastle, headed by the aldermen, came to Tynemouth with the objective of killing the prior. Fortunately, he escaped.

In 1530 Newcastle again petitioned the king, who was now Henry VIII, and secured a prohibition from any ships loading or unloading from any port on the Tyne other than Newcastle but he did permit fishing and salt manufacture at North Shields.

Six years later, however, Henry VIII had broken with the Roman Catholic Church, and was in the process of dissolving the monasteries in his self-appointed role as 'Supreme Head on Earth of the Church of England'. The smaller monasteries had been dissolved in 1536 and a subsequent Act of 1539 allowed for the dissolution of the larger monasteries. It was a matter of grave concern for the poorer people of England who often relied on the charity of the church to exist.

There is a lighter note that, while not relating to Tynemouth, is worthy of mention. It is said that the children's nursery rhyme 'Little Jack Horner' relates to the dissolution. Thomas Horner was steward to the abbot of Glastonbury and to conceal the assets of the

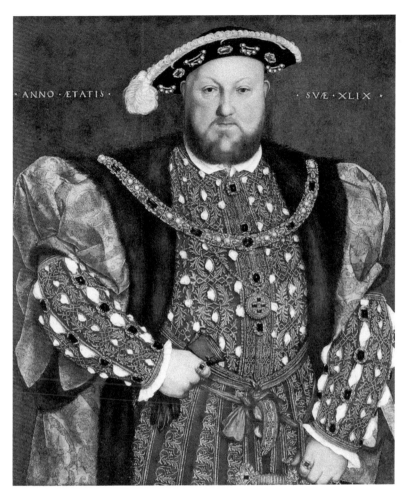

·ANNO·ÆTATIS· ·SVÆ·XLIX·

King Henry VIII.
(Courtesy of the
National Portrait
Gallery)

monastery it is said that the deeds for twelve estates were concealed within a pie. This is not as far-fetched as you might imagine as foot pads were in abundance, and travellers would often conceal assets within the hems of clothing or indeed within a cake or pie.

Horner was apparently given the job of taking the pie to London, which may have been in an effort to persuade the king to be lenient with the monastery or possibly to conceal the deeds in London for collection at a later date. Horner is alleged to have opened the pie while travelling and removed the deeds for the manor of Mells, which was rich with lead mining. (The Latin for lead is *plumbum*, hence the line 'pulled out a plum'.) He is said to have stolen the deeds for this manor. What is true is that Thomas Horner did become the owner of the manor of Mells but the family have always insisted that the manor was purchased legitimately.

Returning to Tynemouth Priory we know that on 12 January 1539 the commissioners appointed by Thomas Cromwell, on behalf of Henry VIII, arrived in the Tyne. On arrival they continued by boat up the Pow Burn, the inlet that ran from a point close to where Clifford's Fort now stands.

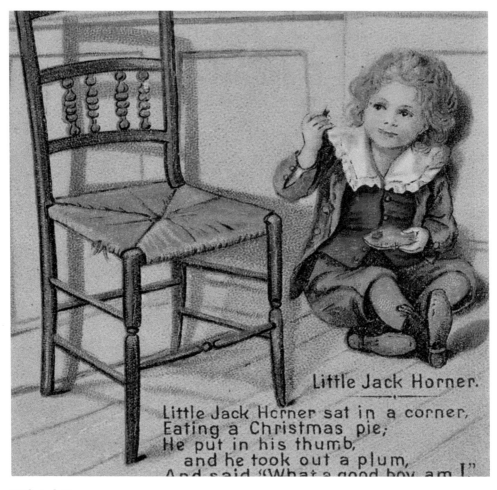

Little Jack Horner.

Little Jack Horner sat in a corner,
Eating a Christmas pie;
He put in his thumb,
and he took out a plum,
And said "What a good boy am I."

Little Jack Horner.

Although now barely discernible other than within Northumberland Park, the Pow Burn once flowed as far as the district of Preston. The commissioners disembarked at the point where the Governors Tree stands on what is now Tynemouth Road.

From there they will have proceeded directly to the priory where Prior Robert Blaykney and the eighteen monks and novices will have been waiting. The prior and each monk and novice were obliged to sign a document surrendering the priory and all the assets and estates over to the king. They were all then given what was described as a pension, but in the twenty-first century we might call a redundancy payment, and were then escorted from the priory to make their own way in the world. The total assets owned by the Priory were assessed at the time as being worth around £7,061. In modern times this equates in purchasing power to around £3 million.

The departure of the prior meant that the people no longer had the protection against neighbouring Newcastle and for a while North Shields again declined, but another battle with Newcastle was not too far away.

Governor's Tree.

The 1530 Act had permitted North Shields the right to manufacture salt and it had continued to do so. Salt will be dealt with in depth in a subsequent chapter so suffice it to say that salt was an important factor in the survival of North Shields.

The battle with Newcastle that I referred to earlier came about in 1650 when Ralph Gardner set up a small brewery in Chirton, an area close to North Shields. He had been born in Newcastle in 1625 and in 1648 married Catherine Reed and the couple lived in a small cottage in Chirton. As stated, he set up a small brewery and the operation enraged the Newcastle brewers, who warned him to stop trading but he refused to do so. They then imposed a fine on him. He refused to pay, In 1652 he was arrested and placed in prison without trial. Applications to have him released were made but each was ignored. In February the following year he escaped and fled initially to Scotland before returning home.

An armed gang from Newcastle arrived in Chirton intending to arrest him under the pretence that they had a warrant for unpaid debt. They shot at his servants and beat his wife but fortunately some seamen witnessed what was happening and attacked the Newcastle gang and disarmed them.

Knowing that another attack would follow, Gardner set off for London. Fortunately he was supported by many wealthy individuals including Sir Ralph Deleval. Initially he made the circumstances known to people of influence and then he petitioned Parliament for the right for his and other businesses to trade freely. His petition went before the appropriate committee in October 1653 and they approved his plea with a number of recommendations that would enable free trade all along the River Tyne and effectively revoke all of the previous powers and charters held by Newcastle.

The recommendations and a bill supporting them were to be put before Parliament on 13 December 1653 and was virtually assured to be successful. The Parliament in question

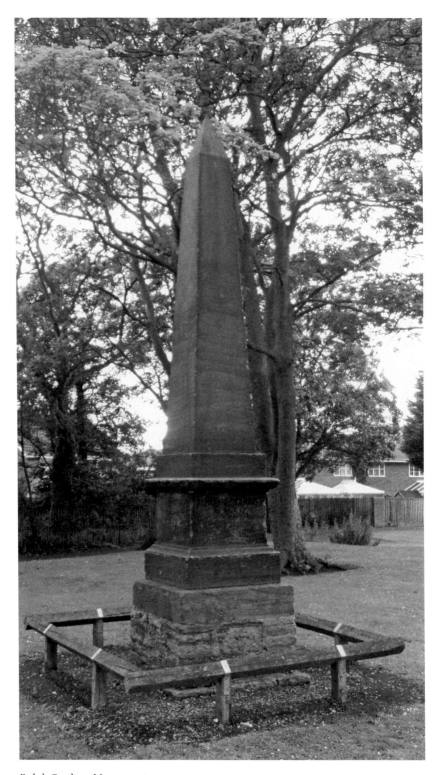

Ralph Gardner Monument.

had been set up in July that year by Oliver Cromwell. Its official title was the Nominated Assembly but has gone down in history as being the Barebones Parliament. From the very start there had been bickering and infighting and the 12 December 1653 was the date that Cromwell finally lost his patience; he sent troops in to clear the assembly and instead appointed himself Lord Protector. Had Cromwell deferred his action by only a few days there is little doubt that on 13 December Parliament would have created a situation on Tyneside that did not come into being until the nineteenth century.

Clifford's Fort was built in 1672. At that time there had already been two Dutch wars. In the main they had been disputes over ownership of colonies. The third, however, related to a secret treaty that King Charles II had entered into with King Louis XIV of France, which promised to support France in its own war with the Dutch. There was a genuine fear that the Dutch may attack ports such as North Shields or Newcastle.

Newcastle continued to dominate its neighbour for many more years. However, at the start of the eighteenth-century economic attitudes began to change. With increased international trading the idea of local rivalries become trivial and gradually North Shields began at last to flourish as an independent town.

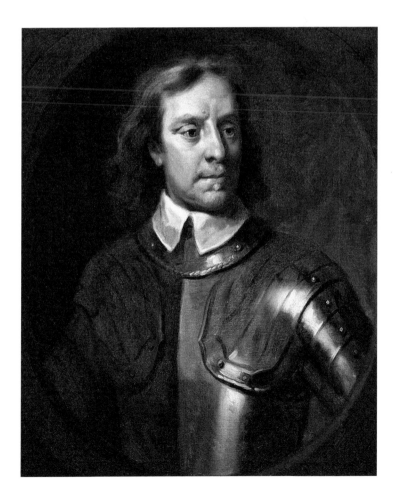

Oliver Campbell.

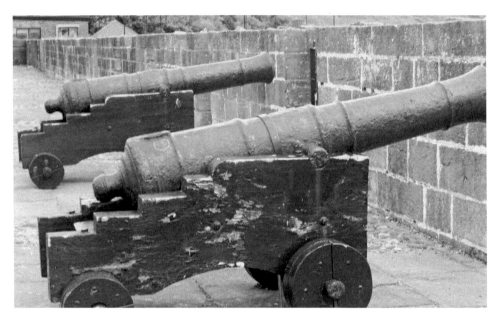

Clifford's Fort.

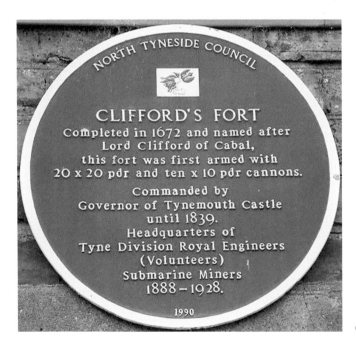

Clifford's Fort plaque.

2. Life on the River and the Sea

The river and sea have always been an integral part of life at North Shields and Tynemouth, whether it was the provision of shields for fishermen and the benefit of their work or the production of salt, but much more of North Shields' life had been water related. We have already seen that the prior and monks of Tynemouth had an active interest in both fishing and salt production.

The early vessels of the thirteenth century were capable of travelling as far as Iceland and it is inevitable that the need for repair and maintenance of these vessels was crucial. A small network of repair businesses grew as did building the vessels in the first place.

Coal had been in use as far back as Roman times but trading in coal began in earnest in the thirteenth century and by the end of that century a whole fleet of vessels were transporting coal from the Tyne to London. In 1377 alone 70,000 tons of coal made its way along that route. By the mid-sixteenth century coal was being shipped to France.

Typical thirteenth-century vessel.

Coal was measured by a cauldron, which was a peculiar measurement used in coal. A Newcastle cauldron was different to that used in London. In 1421 it was agreed that a Newcastle cauldron represented 2,000 lb while a London cauldron equated to around 3,140 lb. It was not standardised until 1831.

In Newcastle the price of coal was eleven pence per cauldron. In France the price for a cauldron was £4, so the export to France was of massive importance and large quantities of coal were shipped to France whenever it was possible, although frequently it wasn't possible due to various wars.

North Shields was an attractive port to all kinds of ships as it lay so close to the harbour entrance and avoided the hazardous journey of navigating the various twists and turns to reach Newcastle. It didn't help that the level of the water in Newcastle often lowered, leaving ships stranded for sometimes as long as three weeks. This was just one of the causes of frequent friction between Newcastle and its coastal neighbour.

The Black Middens

Even docking a vessel in North Shields came with its own problems in the shape of the infamous Black Middens. Midden is a Scandinavian word to describe a heap of domestic waste. The Black Middens were the cause of many shipwrecks and today a monument stands to the memory of sailors and fishermen. Given the name Fiddlers Green, it immortalises the legend of a special heaven for seafarers. Various legends grew up surrounding the origin of these treacherous rocks, which are sometimes concealed under water and at others stand proud close to the entrance into the River Tyne.

Fiddler's Green.

Over the centuries many ships have come to grief because of the Black Middens. In 1536 Henry VIII ordered the construction of two towers, the Low Lights and the High Lights, which were designed and positioned so that ship navigators could align with the two and ensure a safe passage into the harbour. By 1672 the buildings needed extensive repair and were rebuilt in 1727. The Old Low Lights is now a heritage centre.

The course of the river shifts over a period of time and in the early 1800s it was clear that the old towers no longer gave accurate guidance and so the new Low Lights and High Lights were built between 1808 and 1810.

The world's very first lifeboat was built in 1789 by William Wouldhave, who was born in Liddell Street, North Shields. Sadly, by the time he invented it he was parish clerk for South Shields so the glory for that must go to the rivals across the river. The Duke of Northumberland then ordered a similar boat called *The Northumberland* to be based at North Shields.

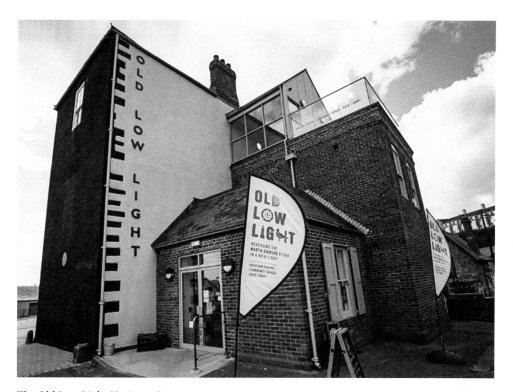

The Old Low Light Heritage Centre.

Black Middens.

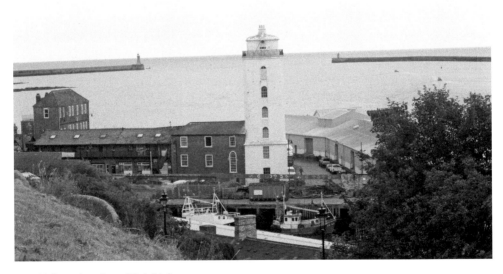

Low Lights taken from High Lights.

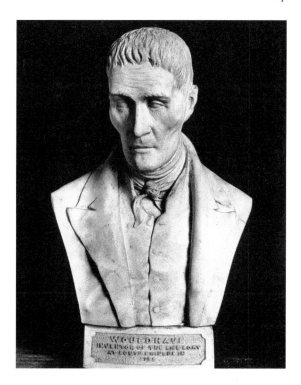

William Wouldhave.
(Courtesy of J. H. Cleet)

Tynemouth Volunteer Life Brigade

However, Tynemouth and North Shields are rightly the founders of the Volunteer Life Brigade, which today is known as the Coastguard Rescue Service having recently changed its name from Auxiliary Coastguard Service. It was a tragedy in 1864 that brought it into existence.

Despite the Low and High Lights presence many ships have crashed into the Black Middens over the centuries. One example had been the *Betsy Cairns*, a ship that began life in 1699 as the *Princess Mary* and had been the royal yacht for King William III, Queen Anne and King George I. By the early 1800s she had become a collier brig. On 17 March 1827 she set off laden with coal intended for Hamburg, but snow and a heavy south-easterly gale drove her back to Tynemouth and was forced onto the Black Middens. Although the crew made it to safety the ship itself had to be sold for salvage.

The most significant period, however, was one period of three days of storms in November 1864 when five ships were wrecked on the Black Middens. This period of storm has gone down into local folklore and it is known that on 24 November 1864 a fierce south-easterly gale caught two particular ships.

The Tynemouth Volunteer Life Brigade have a detailed account available within their excellent museum at the Spanish Battery in Tynemouth but other accounts are also available from the investigations carried out into what happened. Each is slightly different, not because anyone is telling lies but the same incident is seen in different ways according to where the person reporting was at the time. In addition, so much was happening at once that no one had time to make notes or check the time.

Sinking of *Betsy Cairn*. (Courtesy of artist James Richardson)

It was a horrific incident with two ships crashing onto the Black Middens in such a close proximity of time, people were desperate to help and the screams of the victims will have torn through the air. It must have been an incredibly muddled and harrowing experience for all involved, whether they were rescuers, victims or those helplessly watching from the shore. The following is a brief summary of what happened. It will not match up with every report but it is my understanding from reading all of the reports.

Firstly, the schooner the *Friendship* made for the shelter of the Tyne but the wind drove her into the Black Middens. Rescues at that time were made by the coastguards, who were also revenue men. In fact, the coastguard staff at Tynemouth stood at just four men, two of whom were army pensioners. In Tynemouth Haven stood the two-year-old RNLI lifeboat station and its modern, self-righting lifeboat *Constance*. The Tyne Lifeboat Institution had three lifeboats: *Northumberland* at North Shields and *Tyne* and *Providence* at South Shields.

At around the same time that the *Friendship* found itself in difficulty the steamship *Stanley* also made for the shelter of the Tyne. In the early afternoon *Friendship*, captained by Samuel Stead, had been sighted making its way towards the safety of the harbour. With the force of the wind and sea behind her she was forced onto the western end of the Black Middens by around 4 p.m. There appears to have been a breakdown of communication as both the coastguard and the lifeboat believed that the other had gone to their aid.

At around the same time SS *Stanley*, under the command of Captain Howling, was also in difficulties. This was a passenger vessel with twenty-six crew, thirty passengers, forty-eight head of cattle and thirty sheep travelling from London to Aberdeen. He too decided to make for the shelter of the harbour at around 4 p.m.

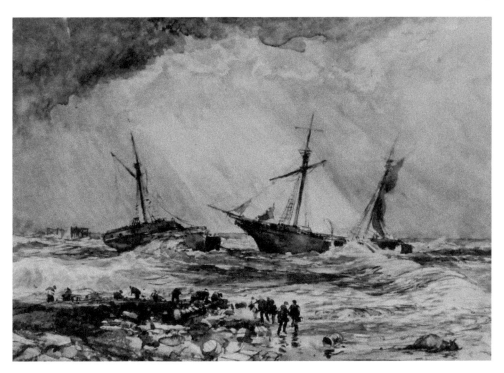

Sinking of *Stanley*. (Courtesy of Tynemouth Volunteer Life Brigade)

A huge wave arose behind the *Stanley* and drove the steamer onto the seaward side of the Black Middens. Initially the coastguards, led by Lawrence Byrne, attempted to use the rocket apparatus, which involved shooting a small rocket from a bracket on land to the ship, so providing a line with breeches buoy equipment with the intention of using this to bring the crew to safety. At around the same time *Northumberland* and *Providence* had been launched but it was impossible to get close enough to the ship to affect a rescue.

Constance then arrived at the scene at around 6 p.m. The coxswain of the *Constance* James Gilbert tried to reach closer to *Stanley* despite being repeatedly swamped by waves of water. As they were about to throw a line a further huge wave washed over the ship and landed in the lifeboat, snapping the oars and washing away most of the spare oars.

Unable to control the *Constance*, the crew had to sit as it was washed towards the *Friendship*. Yet another wave lifted the lifeboat over the schooner's deck and four of the crew fell onto the deck of the *Friendship*. Bear in mind that until this point they believed that the crew of the *Friendship* had already been rescued so they were astonished to find the crew of six still there.

James Gilbert shouted to his crew and the crew of *Friendship* to jump into the lifeboat, which was now back in the water, but before they could do so another big wave carried the lifeboat away from the ship. The schooner lifted on the rising tide, then broke up with the loss of all of her six crew and two of the lifeboatmen. The other two made it ashore. Joseph Bell reached the shore exhausted and made his way to Cuthbert's Cottage where he attracted attention to his plight by smashing a window. The other lifeboatman who

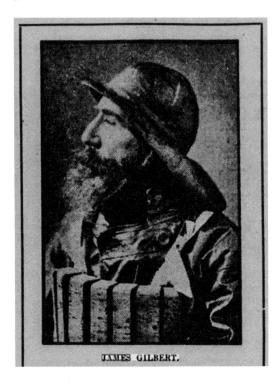

JAMES GILBERT.

Coxswain James Gilbert. (Courtesy of
Tynemouth Volunteer Life Brigade)

survived was James Blackburn from Back Street, Tynemouth. A strong swimmer, he was
in the water for one and a half hours until he was spotted and rescued by Luke Fiddler,
James Ritchie, Ralph Hewison and Christopher Waddell.

Meanwhile the rescue attempts were still being carried out on the *Stanley*. Again, an
attempt was made to carry out a rescue using the rocket equipment, and meanwhile a
boat had been launched from the *Stanley*, which contained nine ladies and four crewmen,
but a davit snapped and the boat was washed away in the sea. Only one man survived.

Back aboard the ship most of the remaining ladies were too scared to use the cradle
of breeches buoy equipment, which seemed the only way to reach the safety of land. A
few of the crew and passengers did attempt it but with only some success: one man was
safely brought ashore, one man had to be returned to the ship half drowned and a man
and woman fell off the cradle exhausted. James Buchan, a fireman, tried but the gear was
fouled and he was trapped in the water. Seeing this several of the men watching from the
shore including a draper, George Bruce, a joiner, James Fry, a plumber, Thomas Cockburn,
and William Ferguson all bravely waded into the water up to their armpits and dragged
him to shore.

At around 10 p.m. the *Friendship* was lifted off the rocks and dragged into deeper water
where she broke up and sank. The steamer later broke in half, the fore section swinging
around so that the bow, pointing into the waves, deflected their force, saving the lives of
those still on board. Everyone left on the stern was swept off to their death.

Rescue attempts continued throughout the night and at dawn it became clear that there
had been at least thirty-two deaths, although the reports on the number of deaths do vary.

Among those who had been watching helplessly was John Morrison, who was an officer in the Rifle Volunteers based at Tynemouth Castle. It seemed clear to him that had the coastguards and lifeboats been supported by a team of trained volunteers then the loss of life would have been less severe. He felt in particular that the launching of the breeches buoy apparatus could have been handled more effectively.

He expressed his views to alderman and former (and future) mayor John Foster Spence and his brother Joseph Spence and in turn they called a public meeting on Monday 5 December at 7.30 p.m., just eleven days after the tragedy. The meeting was held at North Shields Town Hall.

A number of motions were put before the meeting. Firstly, a statement of cordial approval of the action taken by the Tynemouth Relief Committee. Next a proposal that the local people should support the widows and children of the two lost lifeboatmen, James Grant and Edwin Burton Robinson, and a team of twenty-one men were appointed to collect subscriptions to a fund for them. The meeting then recorded their admiration of the coastguards, lifeboatmen and others in their efforts to rescue the victims. Thanks were also given to the ladies who had already worked hard to raise funds and relieve the immediate wants of the sufferers.

Sketch of John Morrison.
(Courtesy of Tynemouth
Volunteer Life Brigade)

BOROUGH OF TYNEMOUTH.

SHIPWRECKS AT TYNEMOUTH.

At a PUBLIC MEETING of the Inhabitants of the Borough of Tynemouth, convened by the Mayor, and held in the Town Hall, on MONDAY, the 5th December, 1864, at Half-past Seven in the Evening.

GEORGE JOBLING, Esq., Mayor, in the Chair.

Mr. Alderman JOSEPH SPENCE, and Mr. A. S. STEVENSON, two Members of the Tynemouth Relief Committee, having explained their objects and proceedings, the following Resolutions were unanimously carried, viz :—

Moved by Mr. J. R. PROCTER, seconded by Rev. H. S. HICKS,

"That this Meeting desires to express its cordial approval of the active and energetic measures of Relief which have been taken by the Tynemouth Relief Committee, and pledges itself to support them in their efforts to alleviate the Distress occasioned by the recent Wrecks at Tynemouth."

Moved by JOHN STRAKER, Esq., seconded by Mr. JOSEPH GREEN,

"That, in the opinion of this Meeting, it is the especial duty of the Inhabitants of this Borough to see that the Widows and Orphans of James Grant and Edwin Burton Robson, whose lives were lost in the Lifeboat Service, are properly provided for."

Moved by Mr. GEORGE KEWNEY, seconded by Mr. Alderman POTTER,

"That with the view of carrying out the foregoing resolutions, and to meet similar emergencies in future, the following Gentlemen, with power to add to their number, be appointed to collect subscriptions, viz:—

Mr J. F. Spence	Mr C. A. Adamson	Mr Edward Pearson
Mr Joseph Green	Mr Wm. Johnson	Mr John Armstrong
Mr John Hedley	Mr John Twizell	Rev. Mr Anstiss
Mr J. R. Procter	Mr H. E. P. Adamson	Mr James Wait, jun.
Rev. H. S. Hicks	Mr George Fawcus	Mr Edward Shotton
Mr M. H. Atkinson	Mr R. M. Tate	Mr Frank Marshall
Mr John Morrison	Mr W. Crighton, Jun.	Mr Joseph Robinson."

Moved by the Rev. F. GIPPS, of Corbridge, seconded by Mr. C. U. LAWS,—

"That this Meeting desires to record its admiration of the gallant conduct of the Lifeboat Men, Coast Guards, and others in their attempts to save the lives of the unfortunate Passengers and Crews of the Steamship 'Stanley' and the Schooner 'Friendship,' and its sympathy with the Widows of Grant and Robson in their sad bereavement."

Moved by Dr. BRAMWELL, and seconded by Mr. Alderman FAWCUS,

"That the most cordial thanks of this meeting be given to the ladies who have so nobly and promptly exerted themselves in collecting funds for, and in relieving the immediate wants of the sufferers."

Moved by Mr. Alderman J. F. SPENCE, and seconded by Mr. JOHN HEDLEY,

"That with a view to assist in saving the lives of those who may be shipwrecked on our shores in future, a corps be formed to be called the 'Tynemouth Life Volunteer Brigade,' the members of which shall be regularly trained in the use of the Rocket Apparatus, &c.; thus having a body of trained men, always able, ready, and willing to assist the Coast Guard when their services may be required; and that the following gentlemen, with power to add to their number, be a committee to carry out this resolution, viz:—

The Mayor (G. Jobling, Esq).	Mr William Twizell	Mr C. H. Greenhow
Mr Alderman Potter	Rev. H. S. Hicks	Mr R. S. Kilgour
Mr Joseph Spence	Mr W. Johnson	Mr P. J. Messent
Mr Stanley Kewney	Mr Stanley Metcalf	Rev. Mr Anstiss
Mr A. S. Stevenson	Rev. R. F. Wheeler	Mr Geo. Bruce
Mr J. Morrison, Tynemouth	Mr H. A. Adamson	Mr J. F. Spence
Mr John Hedley	Mr Wm. Crighton, jun.	Mr T. G. Taylor
Mr George Fawcus		

GEORGE JOBLING, Mayor.

On the motion of Mr. C. A. ADAMSON, the thanks of the meeting were voted by acclamation to the Mayor for his able conduct in the chair.

Borough of Tynemouth, 6th December, 1864.

J. W. SIMPSON, Printer, 53, Tyne Street, North Shields.

Shipwreck poster. (Courtesy of Tynemouth Volunteer Life Brigade)

John Foster Spence. (North Tyneside Council)

The final proposal was worded exactly as follows:

That with a view to assist in saving the lives of those who may be shipwrecked on our shores in future, a corps be formed to be called the Tynemouth Life Volunteer Brigade, the members of which shall be regularly trained in the use of the Rocket apparatus &c; thus having a body of trained men, always able, ready and willing to assist the Coast Guard when their services may be required; and that the following gentlemen with power to add to their numbers, be a committee to carry out this resolution, viz:–

The Mayor George Jobling, Mr Alderman Potter, Mr Joseph Spence, Mr Stanley Kewney, Mr A.S. Stevenson, Mr J Morrison, Mr John Hedley, Mr George Fawcus, Mr William Twizell, Rev H.S. Hicks, Mr W Johnson, Mr Stanley Metcalf, Rev R.F. Wheeler, Mr H.A. Adamson, Mr Wm Crighton jnr, Mr C.H. Greenhow, Mr R.S. Kilgour, Mr P.J. Messent, Rev Mr Antis, Mr Geo Bruce, Mr J.F. Spence, Mr T.G. Taylor.

The meeting was extremely well attended and when the suggestion was made, 141 immediately volunteered. This led to the creation of Tynemouth Volunteer Life Brigade. The idea so impressed the Board of Trade that they passed details to all coastguard stations around the coast with instructions that similar volunteer life brigades be formed at each station.

Because of this tragedy Tynemouth is the birthplace of the Auxiliary Coastguard Service, now the Coastguard Rescue Service.

The Pow Burn
It can scarcely be detected now other than within Northumberland Park but there once was an important tributary of the Tyne feeding into it just below Tanner Bank. It was called the Pow Burn and it ran from Preston Village to the Tyne. It provided drinking water for St Leonard's Hospital, some remnants of which can be seen in Northumberland Park.

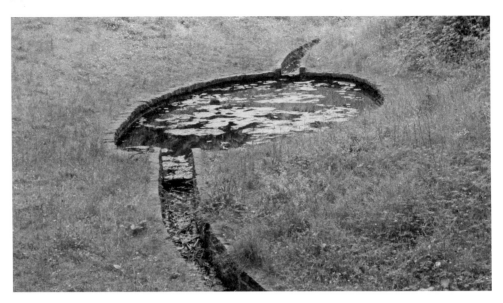

A section of what remains of the Pow Burn.

DID YOU KNOW?
King Edwards Bay, just to the north of the priory, is believed to have been so named due to being the point from which King Edward II with his Queen Isabella and his favourite Piers Gaviston sailed to Scarborough while avoiding Thomas, Earl of Lancaster, who was determined to seize Gaviston. It is worth mentioning, however, that his father Edward I also visited Tynemouth on at least two occasions.

The Pow Burn was the final route for important visitors making their way by boat to Tynemouth Priory. It is on record that the Aldermen of Newcastle travelled this way from Newcastle as the roads were unsuitable for travel.

When Henry VIII closed the monasteries, his commissioners were received here in 1539 on their way to the priory. When Charles I was on his way to his Scottish coronation in June 1633 he first of all visited Newcastle on 3 June where he was received by various dignitaries. The following day he had lunch with the mayor of Newcastle, Ralph Cole, and knighted him the same day.

On 5 June he sailed from Newcastle and he too travelled up the Pow Burn where he was welcomed by dignitaries and escorted to Tynemouth Castle before sailing again en route to St Giles' Church in Edinburgh for his first visit in thirty years since being three years old where he was crowned King of Scotland. The point where all of these dignitaries were met has been preserved with the Governors Tree on Tynemouth Road and immortalised with a blue plaque.

3. Coal

Coal has long been associated with the north-east of England. We know that Romans on Hadrian's Wall burnt coal to keep warm and there are records of coal mining in the eighth century close to Tynemouth.

The commercial production of coal began in earnest in the twelfth century and the monks of Tynemouth Priory were heavily involved. The estates belonging to the priory were not confined in any way to the Tynemouth area as they owned land as far north as Amble and as far west as Wylam and was in receipt of rents from scores of districts.

Mining in those days was not the deep mining we understand today. They took the form of bell pits. The miner would dig downwards for up to 10 metres, and once coal was identified they would dig outwards from that point so creating an inverted bell underground. There were no supports for the roof above the point where the miners were

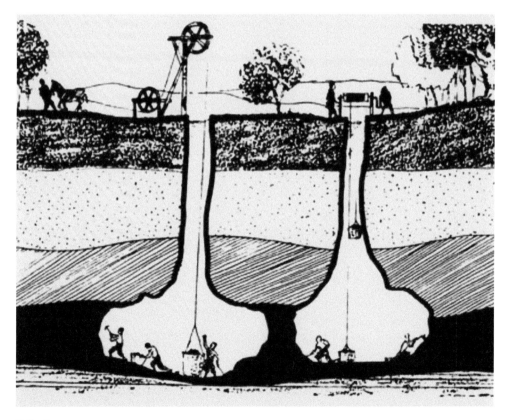

Bell pit.

working so they quickly became unstable, and once that happened or when there was no more coal to be extracted they would abandon the pit and start again in an area close to the original, which would be quickly filled in. A hand winch would be on the ground above and a bucket would be lowered to collect the waste while digging out the pit and later the coal as it was mined.

It is still sometimes possible to see evidence of medieval bell pits by a deep depression in the ground often surrounded by a 'collar' of soil and grass around the edge. We know that in 1316 the priory owned such pits in Merdon, as it was then or Marden as we know it now. In 1376 the priory held mines at Earsdon. When the priory was dissolved on 12 January 1539 the prior personally owned such a mine at Tynemouth. The priory also held mines at Preston, Chirton and Monkseaton.

Although there were the constant battles with Newcastle, Elstewyke, or Elswick as it is now known, lay to the west of the city walls and was a village in its own right, and the priory owned a mansion and land in the area that now houses Elswick Park. The prior owned a mine there in 1330 called Heygrove, which was rented out for £5 per year.

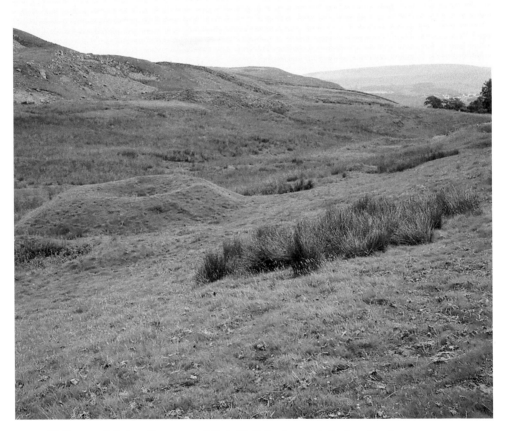

Typical bell pit undulation. (Courtesy of Chris Hall, Scarborough Archaeology)

Tree at Howard Street.

When working underground visibility was a problem and even then they were aware of the risk of naked flames underground. It is recorded that when mining close to the sea, miners would use a rotting fish as they emitted a dim phosphorescent glow that would provide just enough light to allow them to carry out their work.

A pit existed where Howard Street meets Union Street and the site is marked by a solitary tree in a grassed-off area. In later years a theatre also stood here.

Preston appears to have been a particularly good area for extracting coal as early bell pits are recorded there throughout the medieval period. A pit was certainly active in Preston as far back as 1584, which was run by Peter Deleval, a London merchant. At the same time Henry Percy, 9th Earl of Northumberland, owned a mine to the north of nearby Tynemouth. The pits are recorded as being 5 fathoms deep (around 30 feet) and it would take around twelve days to dig that far down.

In 1624 Percy had the rights to coal mined in Murton and Billy Mill Moor and he leased these to Ralph Reed. Flatworth (now approximately the Tyne Tunnel Trading Estate) was leased to Ralph Reed, pits in Preston were leased to William Eden and William Scrivens and Middle Chirton and Monkseaton were leased to Ralph Reed and George Milbourne in 1633. In 1645 the pit at Flatworth was taken over by Ralph Gardner, the valiant campaigner for free trade on the Tyne who featured in chapter

one. It is worth mentioning that when the Old Coast Road was being built in the 1920s a large section collapsed during construction and that was attributed to mining works at Billy Mill Moor.

As the demand for coal grew it was clear that miners would have to go deeper to secure the quantities needed and a huge step forward was achieved when in 1712 Thomas Newcomen, an ironmonger, Baptist lay preacher and inventor, produced the Newcomen Atmospheric engine, an early type of steam engine that was capable of pumping water out of a mine, enabling digging to go much further underground.

The Industrial Revolution was later to provide equipment to make the task even easier but as early as 1735 Longbenton Pit had been dug, which by 1767 was producing more coal than any other in the area. By 1775 deep shafts began appearing in pits between neighbouring Wallsend and Percy Main.

The conditions miners worked under were poor and it was not unusual for men to be expected to work a seventeen- or eighteen-hour shift. By 1825 resentment had grown so much that Thomas Hepburn, a miner at Hetton Colliery near the Wear, created the first miner's union, The Colliers of the United Association of Durham and Northumberland, often referred to as 'Hepburn's Union'. In 1831 the miners went on strike, which had a degree of success in that the working day was cut to twelve hours and the men would

Thomas
Newcome.

always be paid in cash in the future rather than in tokens, which could only be used in shops owned by the colliery owner.

Another grievance was that the colliery owners 'bound' the workers. This meant that each year the men agreed to work for the employer under the conditions read out on a feast day and the miners would then sign it. They had been unable to alter this condition.

In 1832, annoyed at the success of the union, the employers decreed that no man who was a member of the union would be included in that years' binding, due to take place in April. A fresh strike was called but this time the employers stood firm, and evictions from the tied cottages began and miners were brought from other parts of the country to work the mines. After a few weeks starvation forced the men back to work and Thomas Hepburn was blacklisted throughout the area.

A significant point in relation to the Tynemouth area was that during this strike a meeting was held at Chirton on 8 July 1832 and a battle broke out between the strikers and special constables who had been brought in. A miner from Percy Main Colliery, Cuthbert Skipsey, a married man with six children who was known to be mild mannered and not involved in the fighting, tried to make peace between the parties. He was shot in the head by one of the constables, George Weddell. Weddell stood trial for manslaughter and was given a sentence of just six months of hard labour. This was regarded as unjustly lenient as at around the same time a miner who had been present during a murder was hanged and his body hanged in chains near the scene of the crime while the murderer himself had managed to escape.

DID YOU KNOW?
Cuthbert Skipsey's youngest son, Joseph, became the 'Pitman's poet', having taught himself to read and write. Despite his well-recognised poetry skills he was a miner at Backworth for most of his life. Almost living a double life, he met the artist Dante Rossetti and was in receipt of a pension from the Royal Bounty Fund awarded by William Gladstone. At the age of fifty he became custodian of Shakespeare's birthplace in Stratford-upon-Avon.

In January 1855 Thomas Hughes had announced the development of another pit at Preston and on 18 December 1856 it opened for business, extracting coal from 43 fathoms deep (258 feet). Sadly, like so many pits of the time, it had a catalogue of disasters ranging from fires to floods, starting only a few years after it opened.

By 1923 the colliery was owned by U. A. Ritson & Sons Ltd and in December of that year the directors sent a letter to the officials stating no bonus would be paid as the result of the years working of the colliery would not permit it. It went on to stress that no personal blame was being alleged, simply that the quality of the coal produced was of a 'dirty

1832 *(July 8)*.—In the evening of this day (Sunday), Cuthbert Skipsey, a pitman belonging to Percy Main colliery, was unfortunately shot at Chirton, near North Shields, in an affray between some pitmen and special constables, the latter of whom were appointed to protect such of the workmen as were unconnected with the *strike* among the colliers. At the inquest, which was held on the Tuesday at the Rose inn, Willington, before Stephen Reed, esq., coroner, much contradictory evidence was given—the police party stating that there was a general *row*, and that Skipsey struggled with a policeman named George Weddell, to get possession of his pistol, whilst the witnesses on the other side stated that the deceased went up to Weddell to endeavour to make peace, and that Weddell immediately pushed him back and shot him. The jury, after about an hour's consultation, returned a verdict of *manslaughter* against Weddell, who was admitted to bail to appear at the assizes. August 3d, after a trial which continued about twelve hours, Weddell was found guilty of manslaughter, and sentenced to six months' imprisonment and hard labour.

Cuthbert Skipsey.

nature', which is taken to mean that it was not of a good enough quality for domestic use but possibly acceptable for use in steam engines.

It should be noted that what was termed 'Wallsend Coal' was particularly popular in London and Charles Dickens even mentioned it in his novel *Bleak House,* so being unable to produce coal needed for London domestic use will have been a bitter blow. The letter went on to say that the outlook was very bleak but that the company would try to continue, while also advising that they would not be able to carry on at a loss indefinitely. Preston pit closed in March 1928. Before the mass closure of the pits in the 1980s mining had already pretty well come to an end in North Tyneside.

Bleak House.

4. Salt

We think of salt as something used in cooking and as flavouring for food, but its history can be traced back to 6050 BC. The Egyptians used it as a religious offering, while the Phoenicians used it in trade. The word salt gave rise to the words salary and salad. It was sometimes used as currency and in Roman times the Via Salaria in Italy was a salt road based on a Bronze Age route. Salt can also be used as a preservative and in the American Revolutionary War the British intercepted shipments of salt in order to interfere with the American's ability to preserve their food.

Phoenician salt mine.

North Shields too benefitted from salt. The Tyne and Wear Historic Towns Survey of 2004 records that the salt industry at North Shields was greatly encouraged by the use of salt in the preservation of fish. Tomlinson suggests that there were salt pans on the site of the later Clifford's Fort, which worked from AD 800 until the Dissolution of the Monasteries in 1539 and that the Pow Pans were making salt in the reign of Queen Elizabeth l. In 1846 Gibson refers to the accounts for the demesne lands at North Shields in 1539 where the rent for four pans at Shields is included in the rent for the farmer of the demesne lands.

North Shields had the advantage of a large harbour so brine accumulated. Brine is sea water with a high concentration of salt in it. In the simplest of forms the brine is collected and heated in a large pan or 'pann', hence the use of the word 'pann' historically in areas such as Howden. Crystals of salt then formed, which would be raked out and more brine added. The crystals form and separate because salt has a much higher boiling point than water.

The concept is simple but it is time consuming and roughly 5 gallons of sea water will produce three cups of salt. Of course the higher the concentration – the stronger the brine – the more salt will be produced.

We know that the monks of Tynemouth Priory had salt pans by at least the fifteenth century but almost certainly long before that. After the dissolution of the priory four of the pans were leased by the king on a twenty-one-year lease to Sir Thomas Hilton subject to the existing tenancies of Thomas Johns, John Robinson, Widow Weddell and William Davye.

Salt proved such a successful business that in 1634 the various businesses had created the Society of Salt Makers at the North and South Shields and they secured an order that no new salt works could be created on the coast between Berwick and Southampton. This benefited North Shields for many years, but the Treaty of Union in 1706 gave Scottish

1784 sketch by Thomas Rowlandson of a salt pan.

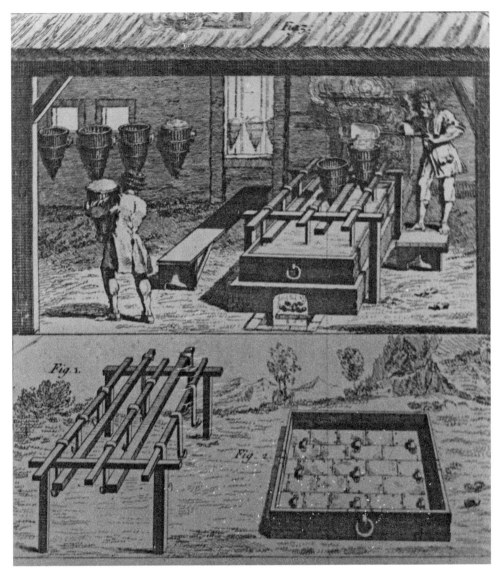

Engraving of the salt pan site.

salt pans total exemption from the English salt tax for seven years after the union and perpetual exemption from two-thirds of it.

Salt production at North Shields suffered and fewer manufacturing sites existed. It was not until 1798 that an Act was introduced that prohibited the importation of Scottish salt into England and salt production had a revival in the nineteenth century. This gave North Shields a massive monopoly and for a while the salt works were more profitable than coal mines.

Between 11 June and 14 August in 1635 Sir William Brereton, the English writer, commander-in-chief of the Parliamentary forces in Cheshire and politician, toured North

East England and visited North Shields and Tynemouth between noon and 7 p.m. on 23 June 1635.

It is worth mentioning that he was already familiar with the process of salt production as his wife's family, the Booths of Dunham Manor in Cheshire, were involved with the salt production, which took place at the River Bollin at Dunham Woodhouses. He recorded that in North Shields he found more salt works and more salt made than in any part of England that he knew. He went on to record that more pans than could be numbered were placed in the river mouth and wrought with coals brought from the Newcastle pits. He referred to 'a most dainty new salt works having been erected there' and went on to say that it was the most complete work that he ever saw. He saw six ranks of pans taking up the breadth of the space with four pans to a rank. He commented that at either side the furnaces were placed in the same way as at the salt works operated by his brother-in-law Booth in Cheshire. The ashes fell into the grate beneath the furnaces, which were covered. A pan was built into the floor between each furnace, which is made of brick, and they too had a cover. The brine was boiled and turned into lumps of hard and black salt. He recorded that these hard and black lumps were then sent to Colchester to be turned into salt and also states that without this supply from North Shields, Colchester would be unable to make salt.

His description then goes into more detail. The six ranks of four pans to a rank constitute twenty-four pans. They have twelve furnaces and twelve fires, all square and of the same size, and they are placed two and two together, one against the other, the six pans in the highest ranks, the bottom equal with the top of the lower furnace.

The higher pans are filled three times until it begins to create salt. A kind of trap door is then released allowing the brine to run into the lower pans, which brings it to a larger proportion of salt. This saves time and fire as it burns for longer with the heat of the upper pan, which can now deal with a fresh supply of brine. The smoke is forced upwards into a chimney.

Twice in a twenty-four-hour period the salt is removed from the lower pans. Each produces two bowls of salt (the word bowl was the word used by Brereton but it is likely that he was referring to the unit of measurement boll or bole. A boll equated to around 145 litres). He recorded that a boll was worth at least two shillings, so, over a year, he estimated that the works would generate annual earnings of £1,400. The national archives price comparison site gives the equivalent modern-day value as being around £164,658.

Two men and one woman were employed to clear the ashes and one to pump the brine and manage the works and recorded that the men were paid fourteen shillings per week. He continued his report by stating that there were a vast number of salt works in the area from single households with small pans to the larger works such as the one he had visited showing that salt was a major industry at the time and in fact salt sold at a far higher price than coal. He actually compared the costs by using the term 'weane load'. One weane load of salt was worth £3 10s (£3.50) while three weane loads of coal was worth only 7s (35p).

It is recorded that the salt pans of Howden needed fifty hundred-weight of coal to produce twenty hundred-weight of salt. Howdon salt apparently had a very high

reputation for its savour and purity. There were, of course, numerous salt pans in the Tyne area over the years. Among them we know of the following.

Peter Delevall owned 'certain salt panns at Shields' in 1594. On 27 August 1600 William Riddell left five salt pans to his wife Barbara and one to each of his sons Michell, John and

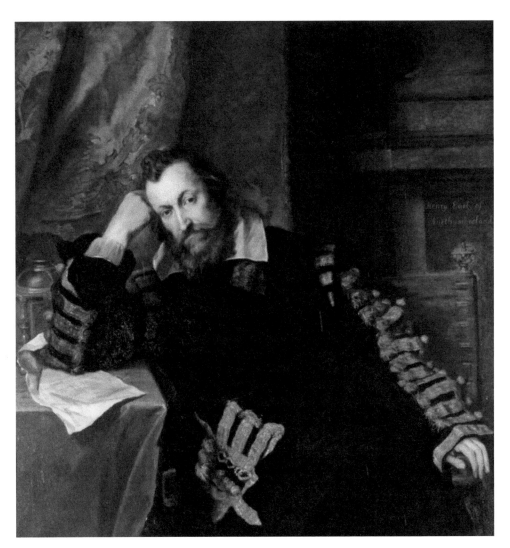

Henry Percy, 9th Earl Northumberland.

DID YOU KNOW?
Henry Percy, 9th Earl of Northumberland, spent some time in the Tower of London accused of being complicit in the Gunpowder Plot.

Robert and two to his daughter, Alice. On 13 March 1623 a grant was made to Henry, 9th Earl of Northumberland, of two salt pans called Stodwenes Pans. A survey in 1707 records ten pans owned by the Milbourne family, seven owned by John Airey, two owned by Michael Coatsworth, three owned by the heirs of Luke Killingworth, two owned by Mark Ollie, one owned by Sarah Chaytor and two owned by the heirs of William Collinson. It is likely that these were larger substantial salt sites and that smaller, less significant ones also existed.

In 1832 the *Northumberland Advertiser* carried an advert offering for sale the remaining two years on a lease of salt manufacturers Foster and Pearson's including all pans and equipment, and application should be made to J. Pearson at Low Lights Raff Yard. In more recent years we know that a salt works was owned by Isaac Cookson and Co., another by J. & W. Maddison and yet another by Ogilvie & Son.

In fact, salt production on the Tyne continued until early in the twentieth century by which time more modern methods of production had been established elsewhere in the country, particularly Cheshire.

5. Northumberland Park

In the early 1800s the area north of the house of correction, which stands on Tynemouth Road, was called Spittal Dene. Spittal Dene Farm was roughly where the golf club entrance now stands. The area between the farm and the house of correction contained the remains of St Leonard's Hospital, which had existed since around 1293 and had been a lepers' hospital. The Pow Burn ran through the land between where the golf club now stands and feeding into the Tyne approximately where Tanner Bank meets the fish quay. The land was a mix of wild and farming land. It was owned, as were other large tracts of land, by the Duke of Northumberland.

As early as 1839 suggestions were being put forward that the land could be used for public gardens for the benefit of the residents of both Tynemouth and North Shields. The *Tyne Pilot Magazine* collected various proposals for the use suggesting serpentine walks with seating arbours and grottos, fishponds, a greenhouse and fountains. After this initial enthusiasm the idea seems to have gone cold until in 1878 the then mayor, Alderman Edward Shotton (1829–84), a steam shipowner, magistrate and Tyne Commissioner, proposed to Henry George Percy, 7th Duke of Northumberland, that he should gift the land to Tynemouth Borough Council so that the park could be built. The duke did make the offer to the council but at that time it was refused.

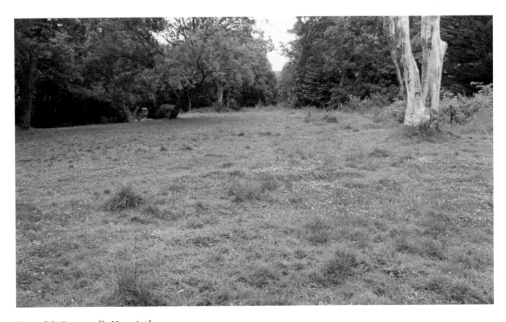

Site of St Leonard's Hospital.

Henry George Percy, 7th Duke of Northumberland.

Edward Shotton died on 5 January 1884 and just ten months after his death the council decided to look again at his proposal to obtain the land from the duke to create a park so sadly Alderman Shotton never saw his dream being fulfilled. Because of heavy unemployment in the area it was felt that the creation of a park could help with the problem. Alderman John Foster Spence approached the duke's agent and the duke was persuaded to renew his original offer.

DID YOU KNOW?
Edward Shotton built his home, Preston Tower, in 1875 and this was sold on his death to the Robinson family of the Stag Line, which was based at the foot of Howard Street in the building now occupied by the registry office.

The layout of the new park was designed by Captain Casimir Thomas Gomoszynski.

DID YOU KNOW?
Casimir was the son of Joseph Gomoszynski, a Polish lieutenant who had been part of the November Uprising against the Russian Empire. When the uprising was crushed his father had been forced into exile and arrived in Britain where he married a Liverpool-born girl in the Scottish town of Greenock, which is where Casimir was born in around 1845. Joseph was a professor of languages and made his living by teaching in a number of establishments in Britain.

Casimir arrived in Tynemouth at some time before 1881, which was a distinctive year for him. He was already an assistant in the borough surveyor's office but was then elected borough surveyor and engineer at a salary of £300 and on 12 October that year married Mary Adeline Beaumont Lee in Morpeth, her home town.

His rank of captain came from his membership of Tynemouth Artillery Volunteers. City and county directories show him as living at No. 41 Linskill Terrace. His work created the network of pathways through the grounds and numerous sycamores were planted, as well as a lake, which was constructed linking with the existing Pow Burn.

The park formally opened on 11 August 1885. It was a major event with special trains being laid on and even the banks were closed for the occasion. The Duke of Northumberland, accompanied by his son, Earl Percy, arrived at 1 p.m. In attendance were the mayor, Robert M. Tate, and the full corporation of Tynemouth along with local justices of the peace and the mayors of Newcastle, Gateshead, South Shields and Jarrow. The official opening happened with the duke planting a 12-feet-high turkey oak and then

Captain Casimir
Thomas
Gomoszynski.

his son Algernon George Percy planted a 9-feet-tall mountain ash just 20 yards away along the main drive.

The finished park had two lakes, one of which had a fountain and waterfall. There were three aviaries, a gardener's cabin and two large greenhouse, which had already existed, having been built by Thomas William Carr, who had maintained gardens and a croquet lawn before the park was developed. When Mr Carr migrated to Australia his brother Robert Cornfoot Carr continued the work. The park keeper's cottage was positioned at the north of the park facing the site of St Leonard's Hospital and had two stone lions at the door.

Turkey oak planted at original opening.

Lion originally at park keeper's cottage.

Sadly, over the years the park fell into some level of neglect, caused principally by vandalism, which led to local people being reluctant to use it. In 2009 a period of major regeneration began with funding from the Heritage Lottery Fund. North Tyneside Council held various exhibitions and fun days, and local residents were consulted with regard to what they wanted to see in the park. To celebrate the 125th anniversary of the opening a party in the park took place, attracting almost 2,000 visitors.

In July 2012 the Heritage Lottery Fund awarded £2.2 million for the regeneration of the park. A further £3 million was provided by North Tyneside Council. The park was closed on 23 September 2013 and the work began. The gates opened again to the public on 20 February 2015 and on Saturday 8 August (the closest Saturday to the 11 August, which had been the original opening date) a celebration day was held. Around 10,000 people attended this event including Mayor Norma Redfern, officials from the Heritage Lottery Fund and members of the Park Regeneration Board. The following Tuesday was the 130th anniversary of the original opening and the formal opening took place on that day. There to officiate was the Duchess of Northumberland, who was also the Lord Lieutenant of Northumberland. Also, in attendance were Mayor Norma Redfern, Ivor Crowther, the head of the Heritage Lottery Fund, officials of the Park Regeneration Board and Mike

Grand reopening. (Courtesy of Mike Coates)

Coates, who was both chairman of the Friends of the Park Group and also a member of the Park Regeneration Board.

The park holds a pet cemetery, which was created in 1949 in response to a request from the RSPCA. There are bowling greens and the site of the old St Leonard's Hospital and some gravestones relating to the hospital have been preserved and can be viewed.

The lions that once stood outside the door of the park keeper's cottage are still in their old position but today a herb garden stands where the cottage once stood. The herbs are selected to reflect those that would have been used in the hospital. Various wood sculptures can also be found and the park is now home to the Powburn Imps. Their various homes can be found in the barks of some of the trees.

In the centre of the park and overlooking the lake the Glasshouse Tera Room can be found, so named after the greenhouse that once stood there. The building also provides an information area with some relics from the old park. There is also an intriguing Himalayan area on higher ground

The lake itself is beautiful with a fountain and attracts many birds including a resident cormorant. An area has been set aside for butterflies and to the southern edge is a large children's playground.

The park is a tribute to those who originally fought for it to come into existence and also to those whose determination brought it back to life in the twenty-first century. Mike Coates deserves specific praise for his consistent loyalty and support of the park and he is the author of a very detailed book about the Pow Burn itself and the park in particular. I am grateful to him for his assistance and support in preparing this chapter.

Pet cemetery.

Pet cemetery.

Gravestones found at site of St Leonard's Hospital.

Herb garden.

Snail sculpture.

A more unusual sculpture.

Door to an imp house.

A larger imp house.

Fountain in lake with a grey heron.

6. The Wooden Dollies of North Shields

The Wooden Dollies are fairly well known to most visitors to North Shields but not as many people know their history. To trace the origin of the tradition we need to travel back in time to a christening on 11 February 1756 of David Bartleman, the son of Alexander Bartleman and his wife Margaret (née Murray). David was one of four children of the couple. It is worth mentioning that David's older brother Alexander had a son in 1803 also called Alexander, who, in 1851, became the second mayor of Tynemouth. In addition, both Alexanders ran Northumberland Brewery, which was merge and became Bartleman and Creighton Brewery. This was around the time that David's sister Anne married Alexander Crighton.

Returning to Alexander and Margaret Bartleman, Alexander Snr, assisted by his wife Margaret, was both a brewer and a shipbuilder and one ship that was built was a coal brig called, appropriately, *The Alexander & Margaret.* Like many ships of the era, the ship had a figurehead, which was in the form of a woman and was supposed to denote good luck. The figure has been described as 'no slim, simpering, Goddess-looking creature, but a bluff, saucy, hearty-looking hussy, with a full flaunting petticoat something in the style of good Queen Bess'.

In January 1781 this ship was captained by the above-mentioned son David and was sailing the Norfolk coast. Also, at sea was a notorious pirate and privateer who went by various first names including William, Daniel and John. His surname, however, was always constant: Fall.

At this time the American War of Independence was ongoing and it should be remembered that France had aligned themselves with the Americans in this war. Fall held a letter of marque from America. This document authorised the captain to capture enemy ships, their crews, and their cargoes. Fall's practice was to demand a ransom from the captain and, once paid, he would allow the ship to travel freely.

The Alexander & Margaret had a crew of ten men and boys and carried only light armaments amounting to one small cannon. On 31 January Bartleman's ship came under attack off the Norfolk coast from Fall's cutter *Fearnought.* The cutter carried a huge crew and was armed with eighteen cannons. Miraculously the much smaller coal brig managed to fight off the attack and make its escape.

Two hours later, however, Fall's privateer again launched an attack. This attack was far more ferocious and Daniel McAuley, the mate, was badly injured and died from loss of blood. Daniel too was seriously injured and obliged to yield to Captain Fall. The ransom was 400 guineas, which, in modern terms, equates to around £72,000. Having paid the

Typical wooden dolly.

ransom, the ship limped into Great Yarmouth but David died of his wounds just two weeks later on 14 February aged just twenty-five.

Alexander had a memorial erected over his son's grave that gave details of the attack leading to his son's death. The memorial recounted that Alexander Bartleman had ordered the erection of the stone over his son's grave to record the gallantry of his son and the bravery of his faithful mate and also to mark the infamy of a savage pirate. It states that on 31 January 1781 off the Norfolk coast and armed with only one 3-pounder cannon and ten men and boys David had nobly defended himself against a cutter carrying eighteen 4-pounder cannons and upwards of a hundred men commanded by the notorious pirate

The Memory of
DAVID BARTLEMAN
Mafter of the Brig Alexander & Margaret
Of *North Shields*
Who on the 31st, of Jan. 1781, on the *Norfolk Coast*
With only three 3 pounders and ten Men and Boys
Nobly defended himfelf
Againft a Cutter carrying eighteen 4 pounders
And upwards of a Hundred Men
Commanded by the notorious Englifh Pirate
FALL,
And fairly beat him off.
Two hours after the Enemy came down upon him again
When totally difabled his Mate Daniel Mac Auley
Expiring with the lofs of blood
And himfelf dangerously wounded
He was obliged to strike and ransome.
He brought his fhattered Vefsel into *Yarmouth*
With more
Than the Honours of a Conqueror
And died here in confequence of his wounds
On the 14th of February following
In the 25 Year of his Age,

TO commemorate the Gallantry of his Son,
The Bravery of his faithfull Mate
And at the same time Mark the Infamy of a
Savage Pirate
His afflicted Father ALEXANDER BARTLEMAN
Has ordered this Stone to be erected over his
Honourable Grave
"Twas Great"
His Foe tho strong was infamous
(The foe of human kind)
A manly indignation fired his breaft
Thank GOD my Son has done his Duty.

David Bartleman's grave. (Courtesy of Charles Sale Gravestone Photographic Resource)

Fall and fairly beat him off. The inscription continues that two hours after the enemy came down upon him again when totally disabled, his mate Daniel Macauley, expiring with loss of blood and himself dangerously wounded, he was obliged to strike and ransom. He then brought his shattered vessel into Yarmouth with more than the honour of a conqueror and died here in consequence of his wounds on 14 February following in the twenty-fifth year of his age.

Two hundred and thirty years after his death a family called Pearce, who believed that their ancestors had been pirates, paid for the restoration and repositioning of the gravestone in St Nicholas' churchyard, Great Yarmouth.

Meanwhile Alexander had recovered the wooden dolly from the ship and had it transported back to his home at No. 23 Front Street, Tynemouth, where he stood it in the front garden. The property no longer has a front garden and the building is now home to The Wine Chambers.

In 1814 the dolly was moved to a position on the Custom House Quay, Low Street, North Shields. This was the first of what has been to date seven wooden dollies. It was situated in one of the busiest places at the time in North Shields. All of the adjacent buildings were involved in trade of one form or another: there were at least fifty public houses, dance houses, coffee houses, chandlers and ropemakers in the vicinity. The dolly was used to haul spars and wood from the quay using rope wrapped around her. Seamen took to cutting chunks off her as good luck charms on their subsequent voyages. This custom led to local urchins also hacking away at her and eventually a group of drunks pulled her out of the ground and cut off her head. This was in 1850. This, of course, was a year before David's nephew became mayor and we have to assume that he already carried some influence.

What is certain is that a new dolly was quickly constructed to replace the first, built by a sailmaker called Hare. She had a shorter life than her sister and just fourteen years later she too was replaced on 22 June 1864, the day before the laying of the foundation stone for the new Low Lights Dock. This dolly had previously been attached to the barque *Expert*. A barque, barc, or bark is a type of sailing vessel with three or more masts, having the fore and mainmasts rigged square and only the mizzen (the aft-most mast) rigged fore and aft. She too was attacked and chipped away at. Her nose was totally hacked off and replaced with an iron one by local blacksmith Robert Pow. Sailors then began drilling holes in coins and nailing the coins to the dolly. This dolly was replaced in 1902, although that was not the end of her. In the 1930s she appeared in an antique shop in Newcastle after the owner, Mr Seery, had bought her from a fisherman's widow. She was subsequently bought by a Dane and it is believed that she now resides in a Danish museum.

The fourth wooden dolly from 1902 was carved by May Spence of North Shields. This dolly did not resemble the previous effigies but was more in line with the typical image of a Cullercoats fishwife with shawl and creel on her back. The unveiling of this dolly included a procession with a band and speeches. Inevitably she too was vandalised for souvenirs and good luck charms. Her right elbow found its way to a hotel in Melbourne, Australia, and the rest of her remains were found in a Whitby breakers yard. She was removed in 1957.

Wooden dolly, 1864.

Wooden dolly, 1902.

In 1958 the fifth wooden dolly was created by Robert Thompson Ltd in Kilburn, North Yorkshire, and it had two mice as incorporated into the figure was the tradition with that company. Mahogany was used to create this figure. This particular dolly still stands but unlike her sisters she graces Northumberland Square in North Shields. She was treated to some refurbishment work in early 2020.

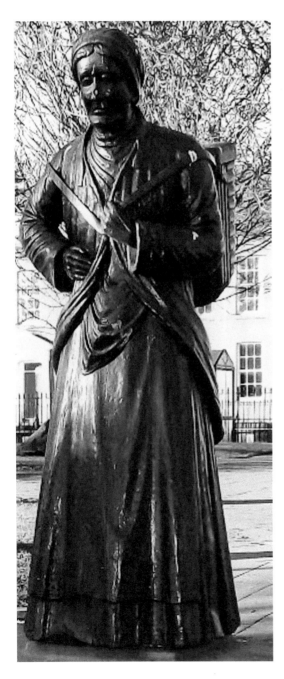

Wooden dolly in Northumberland Square, 1958.

The other end of North Shields was not to be denied its dolly and an additional one was erected beside the Prince of Wales pub, formerly called The Wooden Dolly, on the original Custom House Quay site. This is still there and is a larger copy of the third dolly.

The most recent dolly is in fact only half a dolly as her body is only from the waist up. It was installed in 1993 at the How Do You Do pub, formerly The Wooden Dolly and before that The King's Head overlooking the Fish Quay. Although referred to as a wooden dolly, it is in fact made of clay and cast in plaster. So, a pirate in the eighteenth century is responsible for seven different wooden dollies, three of which still exist.

Wooden dolly, 1992.

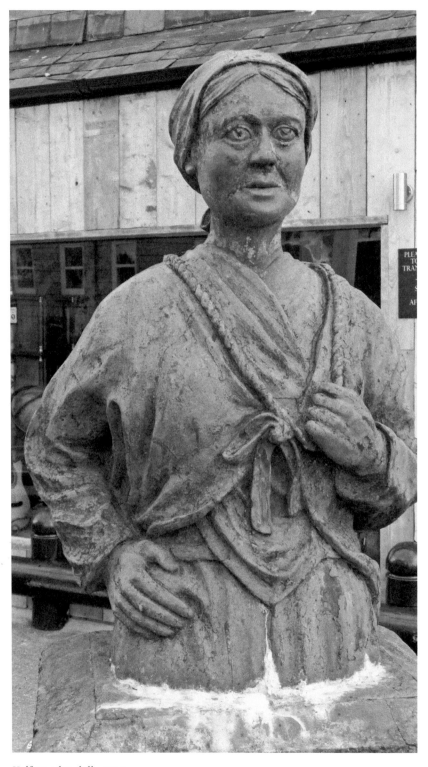

Half wooden dolly, 1993.

7. The People

North Shields and Tynemouth have had numerous people born in, pass through or live in the area who have had great impact on its development. In this chapter I will look at just a small number.

Mary Ann Macham

Mary Ann Macham was not born in North Shields. In fact she was actually born 3,300 miles away in Middlesex County, Virginia, in the USA on 10 May 1802. Her story, however, is important to North Shields.

Born into slavery, her mother was a slave known as Judy while her father was the white son of the landowner. At fifteen months old she was removed from her mother and brought up in the home of her paternal aunt. The account of her life states that she was treated well there during her aunt's life, but when the aunt died Mary became the property

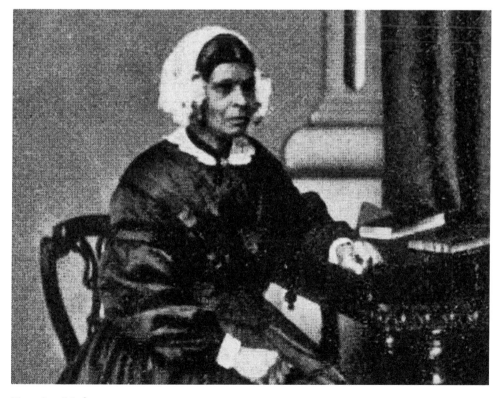

Mary Ann Macham.

of the aunt's daughter, her cousin. The cousin married a man who had accumulated a level of debt and Mary became his property so he traded her in lieu of part of his debt in 1814 aged just twelve years old.

She was then promptly auctioned with 150 other slaves and was sold for $450 and spent the next seventeen years living with her master and mistress. She was treated badly at this farm and recorded in later years that she still had marks on her body from being whipped with cowhides.

At the age of twenty she caught sight of her natural mother but could not speak to her. This was the first time she saw her since she was fifteen months old. The only reason that she knew it was her mother was that Mary was accompanying her mistress to church and the mistress's brother-in-law knew Mary's natural father and it was he who had recognised Judy.

In 1830 she resolved to escape and together with another slave lived in the woods for six weeks watching for a boat that was bound for Europe. On discovering her escape men on horseback were despatched to find her but she managed to avoid capture.

DID YOU KNOW?
In her memoirs Mary recalled that the men hunting her had two bloodhounds with them but she used to feed the dogs and when one did find her she petted it and it left her alone.

After six weeks they sneaked aboard a ship and hid away. Various accounts suggest that a member of the crew, possibly even the captain, helped her stay hidden. Eventually the ship docked in Grimsby and she made contact with Quakers who were sympathetic to her plight and arranged travel to North Shields.

It was now Christmas and she was met by Sarah and Mary Spence. At that time Sarah will have been just sixteen years old and Mary just one year older. It seems likely that these two girls were sent to the initial meeting as they would be less threatening to the former slave than older white male members of the Spence family. The Spences were well established in North Shields at that time not only as prominent Quakers but also as businessmen. Robert Spence, their father, had as early as 1804 been a partner in a linen and woollen draper business in North Shields and was already active as a prominent Quaker in the town. In 1823 he presented an anti-slavery petition to the House of Commons. Robert went on to found a bank in Howard Street, which eventually became a part of Barclays Bank.

On her arrival in North Shields the family found her employment and a home with the Jordeson family in Dockwray Square but records show that she also lived and worked with the Spence family themselves. On 14 August 1841, Mary married local man James Blyth. At the time he was a rope maker living at No. 70 Howard Street but he later became a banker's porter, almost certainly in the Spence Bank. He and Mary then lived at No. 57 and later No. 77 Howard Street.

Sarah Spence.

Her husband James died in 1877 at the age of seventy-six and was buried in Preston cemetery. Mary continued living for a while in North Shields at No. 39 Nelson Street but in 1891 when she died, she is recorded as being of independent means and living with the Ardus family at No. 244 Clara Street, Benwell, Newcastle. She was down on the census as being a relative of the Ardus family. I have investigated the relationship and it transpires that Frances Elizabeth Ardus, the householders wife, had been born Frances Elizabeth Blyth. Her father was Joseph Blyth, the brother of Mary's husband James, so Mary was living with her niece by marriage and her family.

She was buried alongside her husband but the gravestone told nothing of her troubled history. Following extensive fundraising efforts by Old Low Lights Heritage Centre a memorial stone to her was unveiled at Preston Cemetery on Friday 28 February 2020.

Robert Spence and Descendants

In the last section we met Sarah and Mary Spence, daughters of Robert Spence who had been born into a Quaker family. Robert's great-great-grandfather John Spence, born in 1633, had decided to become a Quaker and was one of eighty-one people imprisoned for failing to attend their Anglican church. Robert was born near Harrogate on 10 February

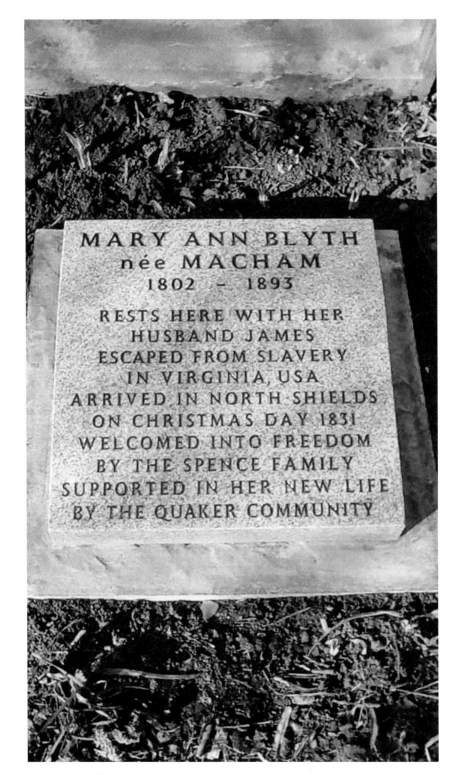

MARY ANN MACHAM's gravestone.

1784. He and his brothers were given a very early form of smallpox vaccine and all suffered smallpox. Two of his brothers died but he survived.

He did not enjoy the Quaker practice of sitting in silence for an hour or more and was prone to fidgeting, earning him a stern look of rebuke from his father. After the service he fled across the fields but this did not save him from what he described as the inevitable whipping from his father. His father died in 1793 at around the time he began as a pupil at Ackworth School, which to this day is one of eight Quaker schools in Great Britain. The headmaster John Hipsley filled him with terror and it was a relief when he was replaced in his post by Dr Jonathan Burns in 1795.

In 1804 he met his cousin Joseph Proctor of North Shields who offered him a partnership in a wool and drapery business in North Shields. In July 1804 he arrived at the Quayside in North Shields to begin his duties and was horrified by what he described as a filthy situation as he crossed the wooden bridge across the Dogger Leitch.

Among the assistants at North Shields was John Foster and they became firm friends. He met John's family including his sister Mary Foster, finding himself greatly attracted to her but was disappointed to learn that another friend had already caught her eye.

It was at around this time that he contracted typhoid and began writing his memoirs, which have helped many researchers, myself included. His recuperation was initially at Toll Square, North Shields, and later at Willington Mill. He then travelled to Yorkshire and found to his delight that Mary Foster was no longer involved in the earlier relationship and on 29 August they married. The business at this time moved to premises on Howard Street, North Shields, and he and Mary occupied the floors above the shop. They had in total eighteen children.

Ackworth School.

Quayside in the nineteenth century.

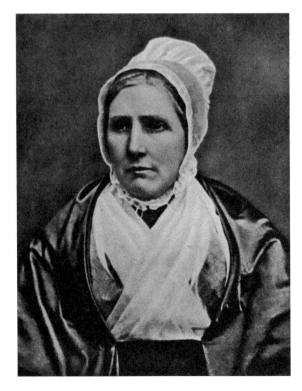

Mary Foster, later Spence.

He was active not only within the Quaker movement but also in business, and in 1818 became a partner in the newly formed North and South Shields Bank at No. 10 Howard Street. In May 1823 he presented an anti-slavery petition to Parliament opposing the ongoing slavery in the West Indies. In 1833 his banking business amalgamated with a Sunderland bank and he continued as manager until 1845. The bank was later absorbed into the Barclays Bank group. He supported and played an active part in many charities in the area and, when he became the borough treasurer of the borough of Tynemouth, he kept the keys to the towns lock up.

In 1848 he suffered a bad fall and was treated twice with being bled, a common medical procedure at the time. Despite this he died on 17 August at home in Howard Street. The Spence family did not fade away with the death of Robert. His son, also called Robert, stepped up to fill not only the bank manager role but also that of borough treasurer. His own sons too became bankers and one of note was Charles James Spence, born on the 20 November 1848. By 1871 he was a banker and partner in the bank called Hodgkin, Barnett, Pease Spence & Co.

Robert Spence Jnr.

ELLIOTT & FRY Copyright 55, BAKER S¹
PORTMAN SQ⁵

He became involved with The Tynemouth Life Brigade and the Society of Antiquaries. In addition, he was an artist of some note specialising in watercolours and engraving. He illustrated the programme for the Students and Lecture Association on 1 April 1886. His drawings included the old priory and lighthouse, the Fish Quay, the High and Low houses and the arms of the new county borough of Tynemouth. In addition, purely for pleasure, he created beautiful etchings of Bamburgh and the Farne Islands and sketched in Sicily and Algiers while on holiday.

He also became treasurer of a number of other organisations including the Willington Quay Local Board, the Chester le Street Union, the Walker Local Board and many others, often succeeding his father in the roles. In addition, he was involved with the Northumbrian Small Pipes Society as had been Thomas and Robert Bewick, the noted engravers and naturalists. They had been friends of both Sarah Foster's father and his own grandfather Robert and his interest in art may have stemmed from that connection.

Tragedy struck his family on 22 March 1902:

GENTLEMAN FOUND SHOT DEAD.
A tragic affair occurred at North Shields this morning, resulting in the death of a son of a well-known resident of the town. It appears that from information received from Dr Rolland, Sergeant King, of the borough police force, proceeded to South Preston Lodge, North Shields, this morning, and found in a workshop at the north side of the house, the dead body of Mr Gilbert Spence, who was 26 years of age, and a son of Mr Chas. James Spence, banker, who resides at Preston Lodge. He was fully dressed, and lying on his back. A five-chambered revolver was near him from which one cartridge had been discharged. He had a bullet wound in the roof of his mouth, and he was lying in a large pool of blood.

The deceased man was last seen alive by the gardener (Mr Dix) about seven o'clock this morning. The sad affair has created a painful sensation in the town, and deep sympathy is felt for Mr Spence and family who are held in very high esteem.

On Saturday last, at South Preston Lodge, North Shields, Mr Gilbert Spence, son of Mr C. J. Spence, banker, shot himself with a revolver. From the evidence at the inquest on Saturday night it appeared that Mr Spence had suffered from insomnia, and the jury found that deceased had shot himself whilst temporarily insane.

Gilbert was one of four children, the others being Robert (known as Bob), Philip and Sarah (known as Sadie). All three were artists. In 1911 Philip exhibited the watercolour 'How Galahad was Brought to Sir Lancelot to be Made a Knight' at the Royal Academy. In addition, the museum at Saltwell Park in Gateshead in 1942 contained a remarkable collection of prehistoric animals and reptiles modelled by Mr Philip Spence. He had built up the models on a paper mache framework, and each specimen had the colouring natural to it in life.

Robert made a far greater impact on the art world and became a full-time versatile artist, settling for much of his life in London One description of him was as follows: 'tall of stature, though stooping of late years; direct and a trifle gruff in speech; no respecter of persons; perfectionist in his work'. When, in later years, he found that his work no

longer found such ready acceptance at the Royal Academy, he was sorry but unperturbed: 'Young whipper-snapper there who doesn't understand about etchings' he grunted after one such visit.

As a Quaker when war broke out in 1914, he was opposed to combat so instead joined an ambulance unit organised by the Society of Friends (Quakers), working with the French Red Cross. The unit treated all wounded soldiers, friend and enemy alike. In 1915 he was based in a first-aid post on the front line near the village of Mesnil-les-Hurlus. In 1915, French troops were advancing against the German army there. Despite the imminent threat Robert was one of the ambulance crew who continued rescuing soldiers and bringing them to safety where their wounds could be dealt with After the war he produced a number of etchings reflecting the scenes he witnessed.

William Harbutt

In 2009 North Tyneside Council erected street furniture to resemble plasticine shapes and colours. Sadly by 2011 these had been removed because of complaints from the public as the design of the seats included a dip and when it rained this dip retained the water for several days, making the seats unusable. The seats were repainted to various colours and designs and relocated elsewhere within the region including a local sixth form college.

Why did the council involve themselves in commemorating plasticine in the first place? It was because William Harbutt, the creator of plasticine.

William, the hero of this account, was born on 13 February 1844 in North Shields, one of eight children of Thomas and Elizabeth Harbutt (née Jeffcoate). His earliest home was No. 63 Bedford Street. William was named after his uncle, his father's only brother who was a missionary in Samoa. By 1861 William moved to Jersey and worked for his brother-in-law William Markus as a bookseller's assistant.

An accident when he was young had left him with a limp, which was with him throughout his life. After that initial working start as a bookseller's assistant in 1869 he began studying art at the National Art Training School (now known as the Royal College of Art) in South Kensington. The qualification he gained when he left in 1873 enabled him to describe himself as Associate of Royal College of Art (A.R.C.A) in the 1890s when the college was renamed. He was qualified to teach elementary and architectural drawing.

When he gained his qualification, he taught at first as a freehand drawing master at Somersetshire College at No. 11 The Circus, Bath, which had once been home to William Pitt the Elder. Alexander Graham Bell, the inventor of the telephone, taught there for a year in 1866.

In 1874 he became the headmaster of the Bath School of Art & Design. A disagreement with the ruling committee led him to leave in 1877 and with his wife Elizabeth (Bessie) Cambridge set up his own school the Paragon Art Studio just yards from his former employer. One of his students was his own nephew Robert Barkas Dawson from Skipton.

Bessie, whom William had married on 8 August 1876, was a noted artist in her own right, specialising in miniatures, and was commissioned by Queen Victoria to paint

William Harbutt.

portraits of the queen and the late Prince Albert. They were originally hung at Frogmore, Windsor, and more recently have been displayed at the Victoria Art Gallery, Bath.

The couple settled at Hartley House, Belvedere, Lansdown, Bath, and it was there that William began experimenting with clay as he had found that the clay used by students was messy and dried too quickly. Using a makeshift laboratory in the basement William began experimenting with various measures of calcium carbonate, petroleum jelly, stearic acid, various aliphatic acids, whiting and perfume. Eventually he produced a non-toxic, sterile, soft and malleable clay that did not dry out on being exposed to the air. The final mix was a bulking agent, principally gypsum, petroleum jelly, lime, lanolin and stearic acid. This was the birth of plasticine.

He obtained his first patent in 1897 and after a period of home experimentation production began out of an old flour mill at the Grange, High Street, Bathampton. As an employer he seems to have been everything an employee could want. He arranged annual outings often involving bussing the entire workforce and their families for a steamship cruise along the Thames. He encouraged ball games at lunch time, often extending the lunch break if a score needed to be determined. If the weather was exceptionally warm, he wasn't averse to sending the staff home early. In the winter, if the water had frozen, he encouraged skating at lunch time on the frozen Kennet and Avon Canal, which ran beside the factory.

Plasticine began as a modelling material for art students and was originally produced as a grey product, but when he moved on to supply in a range of colours it quickly became apparent that it also made an excellent toy for children. He wrote a number of books and pamphlets to explain the product and how it could be used.

Meanwhile William was also active in local politics. He was a district and a parish councillor and stood for election to Somerset County Council.

In 1914 plasticine took a new turn when William applied for a patent for what he described as an improved plasticine composition. The plan was to take basic plasticine and work it into a quantity of lamb's wool or cotton wool in a fairly divided state until a practically homogeneous mass is obtained. The provisional specification goes on to say, 'This improved plastic composition when rolled into thin sheets is applicable to a variety of surgical and other uses as for bandages. It forms a very efficient ear stopping for gunners to prevent gun deafness in ship turrets and forts and for boilermakers using pneumatic percussion tools. It is also applicable in the resetting of broken and fractured limbs and for malformed joints in which case a layer is applied to the limb before the usual plaster case is made and, in many cases making the use of plaster of paris unnecessary.'

It seems that the development was used as earplugs during the war but I have not found any application of the other suggestions. That is unfortunate as some seventy years later a number of employees of shipbuilders successfully took action against various shipbuilders for hearing loss where adequate ear protection had not been provided.

DID YOU KNOW?
During the Second World War, plasticine was used as part of the defusing process for the new German 'Type Y' battery-powered bomb fuse. Plasticine was used to build a dam around the head of the fuse to hold some liquid oxygen. The liquid oxygen cooled the battery down to a temperature at which it would no longer function and the fuse could then be removed safely.

William made many overseas trips, notably to the USA, Australia and New Zealand. On one of those trips to the USA he died of pneumonia in New York in 1921. His body was brought back to England for burial. His descendants continued to run Harbutts Plasticine Ltd. In 1957 the factory was totally destroyed by fire as described below in the appeal action:

Harbutt's 'Plasticine' Ltd v Wayne Tank and Pump Co. Ltd 1970
Harbutts engaged Wayne Tank & Pump to design and install in their factory, an old mill, a pipe system to convey hot molten wax used in the production of Plasticine. Wayne Tank unwisely chose to use plastic piping. Once installed, Wayne Tank chose to initiate the new system at night, but without any supervision. The system had a faulty thermostat and molten wax overheated. The plastic pipes melted and the molten wax

escaped and caught fire, causing a huge conflagration. By the morning, the entire factory was destroyed. This led to one of the biggest-ever claims for damages in England. Wayne Tank sought to rely on a clause in the contract that purported to limit their liability for breach of contract.

The company was sold in due course and since 1963 the product has been manufactured in Thailand.

John Spence

Not to be confused with the Quaker family of Spences, John Spence was born the son of miner Roger Spence and his wife Jane Attis on 9 July 1816 in Percy Main, a small village just outside of the old North Shields.

John Spence.

He began his working life aged just nine years old working as a trapper boy in the coal mine. The job of a trapper boy was very dangerous. They were tasked with the job of opening the trap door to let the coal tubs through, which had to be done very quickly because of the poor ventilation underground and the poisonous gasses. The trapper boys were literally putting their own lives at risk not only because of the risk of the gases but also because of the possibility that if they didn't move fast enough they could be run over and their bodies mangled. He would have had to sit in a small area not much bigger than a fireplace for twelve hours per day always attentive to when the tubs needed to pass through.

In 1828 three Primitive Methodist missionaries began visiting Percy Main. Primitive Methodism was an offshoot of Wesleyan Methodism and was very basic and designed to appeal to the poorer members of society, preaching eternal damnation and salvation.

Miner Henry Wonders allowed the missionaries to use his home for services and in 1828 John Spence began attending the Sunday school held there. The following year in 1829, at a cost of £100, the first Wesleyan Primitive Methodist Chapel was built in Percy Main and in the same year John converted to this religion. Over a period of time John went on to become class leader and then Sunday school superintendent.

His working life too changed and by the age of twenty-one he had set up a small draper's shop in Percy Main. The drapery business flourished and along with it so did his standing in society. He married Mary Hall on 6 April 1842 and they had five children who survived beyond infancy. Mary died on 13 May 1856 and in 1861 he married again this time to Isabella Goodal Carse.

In 1864 because of his standing he was elected Guardian of the Poor and in 1870 was elected to the Borough Council. In 1881 he was mayor of the county borough of Tynemouth and elected alderman in 1884

He died on 9 November 1890 but his name lives on in the local school, originally Tynemouth Grammar Technical School, then Preston High School and now John Spence Community High School. Over the years its pupils have included Hilton Valentine, guitarist with The Animals; Matthew Parr, Olympic figure skater; Sean and Matty Longstaff, professional footballers; Sam Fender, musician; and Niamh Calderwood, author.

Alexander Rollo

There is a grave at Tynemouth Priory that may be of interest to anyone forced at school to learn the poem 'The Burial of Sir John Moore after Corunna' by Charles Woolfe. Just to remind you the first two verses went as follows:

Not a drum was heard, not a funeral note,
As his corpse to the rampart we hurried;
Not a soldier discharged his farewell shot
O'er the grave where our hero we buried.

We buried him darkly at dead of night,
The sods with our bayonets turning;
By the struggling moonbeam's misty light
And the lantern dimly burning.

Alexander Rollo's gravestone.

The relevance to Tynemouth comes in the very last verse where the lantern is mentioned. The lantern was held aloft by Corporal Alexander Rollo, originally from Aberdeen, who married a Tynemouth girl called Margaret Bruce.

DID YOU KNOW?
Alexander Rollo's wife accompanied him to war and during the campaigns she gave birth to ten children.

 He was awarded a Military General Service Medal with three clasps – Roleia, Vimiera and Corunna. The medal was sold at auction in 2014 for £2,000, roughly twice the estimated value. His gravestone was restored in 2003 by English Heritage. It can be found on the southernmost edge of the graves closest to the small bay opposite the car park.

Frank Rayner

Frank was born in 1866, the son of William, a teacher in Kent, and his wife Anne. He married Agnes Appleby in 1896 in Tynemouth and they had had three children, two girls and a boy, but the first girl died aged just five. The family lived at No. 81 Linskill Terrace. He had been a colliery foreman fitter before taking up the sea and he was a marine engineer. His rank second engineer.

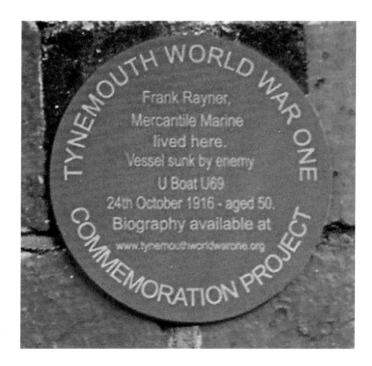

Frank Rayner plaque.

He was on board the SS *North Wales*, a British Steam cargo vessel, which left Hull on 20 October 1916 en route to Canada. On 10 November the Canadian Naval Authority reported that the ship was overdue and at around the same time the German Wireless Press gave the ships name as one which had been torpedoed. It was later established that the sinking had taken place on 24 October 1916 just off the Scilly Isles and it was a U69 that had destroyed her.

Arthur Jefferson

One individual spent his childhood here and became world famous: Arthur Stanley Jefferson. It doesn't ring any bells? Well a glance at the statue within the park may help. He was, of course, better known as Stan Laurel.

Stan's father was also called Arthur Jefferson and rather than regale you with stories of Stan, which you doubtless already know, you may be more interested in knowing about his father as he was a fascinating individual. By the time he arrived in North Shields he was the owner or lessee of several theatres including the Eden Theatre in Bishop Auckland, the Consett Theatre Royal, New Victoria Theatre in Stanley, The Blyth Theatre Royal, a Wallsend theatre and even one in Glasgow.

In North Shields he had the Theatre Royal but not the original, which had been at Howard and Union Streets. This theatre was situated on Prudhoe Street, approximately where a bed shop currently stands. Around the corner on Coach Lane Arthur Jefferson set up a factory to build scenery. He also leased the Albion Assembly Rooms at the corner of Howard Street and Union Street.

Arthur Jefferson. (Courtesy of Danny Lawrence)

This all implies that Jefferson was a wealthy man but that had not always been the case. When he first began his working life, he was a jobbing actor travelling the country from theatre to theatre. He was born apparently illegitimate. Even the date of his birth is a mystery, although he claimed it to have been 12 September 1862.

I must say at this point that a Dr Danny Lawrence carried out extensive research into Stan Laurel and Arthur Jefferson and I would recommend his books to anyone wanting a more in-depth report on the individuals. I freely acknowledge that much of my information relating to Arthur Jefferson came from Dr Lawrence's book *Arthur Jefferson: Man of the Theatre and Father of Stan Laurel.*

His research makes it clear that Arthur was brought up by Harriet Wilson, who for a little while had been married to Christopher Jefferson. However, it is extremely unlikely that Christopher was his father and even possible that Harriet was not his natural mother.

Colonel Alexander Clement Foster Gough was a wealthy, single Wolverhampton solicitor and Harriet Wilson certainly had a long intimate relationship with Gough. He did assume responsibility for her eldest daughter Clara, who may or may not have been his natural daughter. Other daughters followed – Emily and Alice. Harriet adopted the surname Gough for herself and for all three girls, even using one of Goughs middle names and his surname as middle names for Alice so that she became Alice Foster Gough Gough!

In 1861 yet another daughter was born and she was called Mary Ann Foster Gough Gough. Although the relationship continued, it is known that before Arthur was born, the solicitor Alexander Gough had formed a close friendship with the actress Bessie King and there are suggestions that Arthur may be the result of that friendship and that Harriet was persuaded to bring him up as her own. In true chauvinistic style Alexander Gough embarked on yet another relationship with a Fanny Morgan in around 1862 near the time that daughters Alice and Mary Ann had died. Despite this in 1866 Harriet gave birth to another child of Alexander Gough, named William Alexander Gough.

By 1881 when our Arthur Jefferson had left home he called himself Arthur Jefferson rather than Arthur Gough, and this apparently pleased Alexander Gough, presumably as it showed he was standing up on his own and not dependant on Gough. In 1892 when Alexander Gough died, Arthur was named as a beneficiary of his will in the sum of £500. Apparently, this would be in the region of £660,000 in 2017 terms. It is this bequest that allowed Arthur to move away from the role of jobbing actor and become a theatre owner and indeed put on many plays himself.

Dorothy Mitchinson

Linskill School opened in 1932, one half for boys and one half for girls. The girls side had a bungalow in which the girls were taught housewifery skills such as washing ironing cleaning and cooking. One of the pupils in the 1940s was Dorothy Smee. She loved every moment of her school days and when the school closed in 1984 and reopened as a community centre, Dorothy, by then Dorothy Mitchinson, became active providing a craft class. However, in 2005 the council announced their intention to close and demolish the building in order to build housing.

Dorothy was furious and led a band of protestors to make the council think again. She had a small personal army of her own as by then she had seven adult children and three adult step children all with their own children. She set to leading marches and protests, organising petitions, arranging coffee mornings and jumble sales to raise funds for the campaign to continue. The battle continued until the following year when the council backed down and the community centre was allowed to continue, doing so to this day.

As a result, in 2016 in the New Year's Honours List Dorothy was awarded the British Empire Medal for her services to the community. The medal was officially presented to Dorothy on 20 August 2016 within the Linskill School building by the Lord Lieutenant of Tyne and Wear, Susan Winfield OBE. Dorothy attended a garden party at Buckingham Palace with her youngest daughter Yvonne, and, as one of her sons-in-law, I had the privilege of accompanying her to a garden party hosted by the Bishop of Newcastle Christine Hardman.

Sadly, Dorothy passed away peacefully on 17 May 2020 while I was compiling this book.

Dorothy Mitchinson.

Dorothy Mitchinson's
BEM Award.

Many More Celebrities

There are of course many more well-known people who were born in, lived in or simply passed through North Shields and Tynemouth. Here are a handful.

Myles Birket Foster, Thomas George Purvis and Victor Noble Rainbird, all artists. Tom Hadaway, the renowned playwright who began his life in the fishing industry, and Robert Westhall (Atkinson), the children's writer. Byrom Bramwell, the brain surgeon, and his son Edwin Bramwell, the neurologist. Thomas William Brown, the youngest ever recipient of the George Medal, and John Herbert Hedley the First World War flying ace. Rod Clements of Lindisfarne, Hilton Valentine of the Animals, Sam Fender and Neil Tennant, all musicians. Thomas Burt, the miner who became a Member of Parliament. Actress Katy Cavanagh and Tony Scott, the film director. There are many more but space prohibits listing them all.

8. North Shields Theatres

Theatre has played a part in the life of North Shields and Tynemouth for at least the best part of 300 years.

New Theatre (First and Second)

The earliest theatre of which we have a record goes back to 27 September 1765. However, its name itself suggests that there had been an earlier one, which was called the New Theatre and was opened by Thomas Bates. The exact site is uncertain but is likely to have been on the Low Street area as that is where the bulk of the population lived. It is also conceivable that it was on the bank that now rises to Tyne Street.

Records do show that it had both a pit and a gallery, and that tickets for the pit were on a Friday and the show began at 6 p.m. The season of plays, certainly for the first year, was only two months and in subsequent years ran from October until December. It is not known whether the building was used in any other way in the remainder of the year.

Thomas Bates controlled a travelling retinue of performers who appeared at theatres elsewhere in the north-east for the remainder of the year. Thomas Bates ran the overall company and for some years he delegated the running of the theatre itself to his son-in-law James Cawdell, a singer and comedian. Cawdell produced a book entitled *The Miscellaneous Poems of J. Cawdell, Comedian*. Tthe book is dated 31 October 1784 and inside is a dedication to Lady Liddell:

> Dedicated to Lady Liddell
> The author of these miscellaneous poems owes many obligations;
> Her frequent and generous patronage of him in his professional capacity claims his most sincere acknowledgement;
> And her ladyship's polite acceptance of the following trifles confers so distinguished a favour on him that gratitude and not language must shew his sense of the obligations

Lady Liddell was the wife of Sir Henry George Liddell of Ravensworth Castle and they were the grandparents of the Alice who inspired Lewis Carroll to write *Alice's Adventures In Wonderland*

> **DID YOU KNOW?**
> Bizarrely the son of Sir Henry and Lady Liddell was portrayed by the actor Terence Alexander, acting as Lord Ravensworth in the 1985 *Doctor Who* series.

Cawdell's book does not give a clear indication as to his style of comedy sadly as the contents include obituaries, an interpretation of a bible scene, a poem written when he was fourteen years old on his sick bed and the frustrations of the cast when they were stuck in Yarmouth waiting for the winds to be favourable to enable them to sail to North Shields for their next performance.

In 1783 Cawdell had closed the original theatre and opened a second New Theatre, which was positioned at the corner of Howard Street and Union Street, very much where the entrance to the medieval coal mine had once stood and where there is now a grassy area with a single tree standing.

This theatre was better equipped than the former with boxes in addition to the pit and gallery. In order to entice the wealthier patrons, it was designed so that carriages could drive close to the doors. The previous theatre was far less accessible. Cawdell also secured a more professional troupe of actors than had previously been employed. Ticket prices in 1796 indicate no change in admission costs and the new boxes secured two shillings and sixpence.

In 1798 this theatre closed and the building was used as a Dissenters meeting house.

Howard Street Theatre

James Cawdell had begun building this theatre in 1797 partially financed from his own funds and with twelve subscribers each investing £50. The theatre opened in early 1798. When James Cawdell died two years later, Stephen Kemble took the management over while the building remained in the hands of the Cawdell family.

Kemble was a larger-than-life character. He was part of an acting dynasty: his father Roger was a strolling player and actor and was the grand-nephew of recusant priest John Kemble, who was hanged in Hereford in 1679. Stephen's mother was an Irish Protestant actress, although within the family the boys were brought up as Catholics and the girls as Protestants.

Born George Stephen Kemble on 21 April 1758, he became famous for playing the role of Falstaff in prominent theatres throughout the country. It appears, however, that acting was more of a hobby and he was a very successful eighteenth-century theatre manager. He managed Newcastle Theatre Royal for fifteen years, taking over the Howard Street Theatre in 1800.

As was the practice Kemble managed a troupe of actors who would perform in North Shields on Tuesdays and Thursdays and in Newcastle on the other days. Robert King, in his 1947 book, records:

> As wages were small, the actors, if not the actresses, had usually to walk the roads. There is a story dealing with this point. Dissatisfaction had arisen in the company over wages and other matters and Mrs. Kemble, in a moment of exasperation, had said that those who were dissatisfied might leave as soon as they chose 'for there were actors to be got on every hedge'. Shortly afterwards an actor, Liston was walking with others from Newcastle to North Shields when he saw Mrs. Kemble's carriage overtaking them. At once he clambered to the top of the hedge and began examining the brown, leafless branches and when Mrs. Kemble, seeing him, demanded to know what he was about,

replied: 'Looking for actors, ma'am, but I can't find a single sprout.' The lady, it is said, was pleased with Liston's good-humoured retort and invited him to finish the journey in the carriage.

Kemble managed the theatre until 1806 when he retired and there was a succession of managers over the next twenty-five years with varying degrees of success. Gas lighting was installed in 1826 and for the first time the stage could be lit while the auditorium was in darkness and vice versa. Previously candles had lit the entire inner building.

In 1831 William Roxby took over management of the theatre. He sometimes used the surname Beverley as this had been his birth town and his actor father Harry Beverley used it as his stage name. In his first year Roxby put on forty-one performances between the end of November and mid-March the following year. The performances were four hours of entertainment, starting at 6 p.m. and ending at 11 p.m. The evening did not consist of one play as we might expect today, often involving three or four plays plus a performance of songs or recitals. Between 1836 and 1839 Roxby carried out extensive updates including enlarging the stage, a new ceiling, and improvements to the boxes and gallery.

Roxby died in 1842 and his son Samuel and widow took over the business. In 1848 Samuel bought the building itself from a Miss Cawdell, a relative of James Cawdell. Three years after his purchase, however, the theatre was burnt to the ground on 1 December 1851. Despite this setback Samuel had a new theatre built on the same site and it opened on 8 November 1852. This theatre was more ornate than its predecessor and it became a serious playhouse with dramas and Shakespearean plays. Roxby ran it until 1861 when the management passed into the hands of Henry Powell, who took its theme back to its earlier days with songs and dances in between plays and sketches.

DID YOU KNOW?
During the building of the new theatre in 1851 three coffins were dug up and it is believed that they contained the remains of French prisoners of war who had died in a prison on the site during one of the various eighteenth-century wars with France.

He introduced lime lights to the theatre, which meant that instead of the lighting being shared between the audience and the cast the audience could be in a dimmed area while an early kind of spotlight illuminated the actors. The real highlight of Powell's time at the theatre was to bring Gustavus Vaughan Brooke to the theatre for a week in 1862. Brook was an Irish-born international actor who had not only performed in Ireland and England but as far afield as Australia, America and New Zealand. He died just four years later aged forty-seven.

In 1864 Powell relinquished management and a number of managers followed with varying degrees of success, In 1868 it was transformed into a music hall but that was short lived and by August 1876 it was sold at auction, demolished and replaced with the Royal Assembly Rooms. That too closed and was converted into a factory.

Northumberland Music Hall

Other forms of entertainment were competing before the above closure and from the 1860 a wooden building on Borough Road had been competing for audiences. In 1874 Samuel Robertson Chisholm opened it as a music hall. An advert of the time boasted that it would hold 2,500 people and was open each evening and during the summer closure would be available for equestrian shows and performances by the Christy Minstrels. The Christy Minstrels had been created in 1843 in America. Various members had formed their own offshoot troupes over the years performing in England from around 1857. Essentially, they were an early version of the Black and White Minstrel show that readers of a certain generation will recall were popular on television in the 1950s and 1960s. They were a black-faced singing and dancing troupe. It was the sort of show that would be immediately banned in these more enlightened times.

On 9 December 1878 a heavy snow fall caused the roof to collapse and the music hall closed. Chisholm went on to build a new Theatre Royal but more of that later.

Siddall's Music Hall

On 8 September 1876 Samuel Broadbent Siddall, Yorkshire born and living in South Shields where he already owned the Royal Alhambra Music Hall, opened Siddall's Music Hall on Monday 18 September 1876 on King Street in North Shields.

Why this venture failed is unclear. However, if Siddall operated the same policy that he had in South Shields, that of prohibiting alcohol in the auditorium, then we may get some idea.

The Grand Theatre of Varieties/Theatre Royal, Prudhoe Street

This was the next venture by Samuel Chisholm after the roof collapse of his Northumberland Music Hall. It first opened on 22 December 1879 with Tynemouth Brass Band greeting the first patrons with a performance staged on the outside balcony of the building as they arrived. One of the performers that first evening was Rowley Harrison, a contemporary and friend of the famous Joe Wilson, but his name has almost been forgotten today and yet he was a performer much in demand. Like Joe Wilson he was a comedy poet and created an alter ego by the name of Geordie Black. So popular was this imaginary persona that a pub opened under the name and Rowley ran it for a while as well as the Commercial Inn in Winlaton and various concert halls of his own. In his time, he could probably be regarded as an early Bobby Thompson.

The fact that the theatre opened that day is itself a miracle as a gas explosion had rocked the building earlier in the day causing some damage to the seating and the ceiling, but hasty repairs enabled it to open as planned. With the various competing venues in North Shields good marketing was essential and the outside balcony was part of that marketing plan. Various members of the cast were parading in costumes

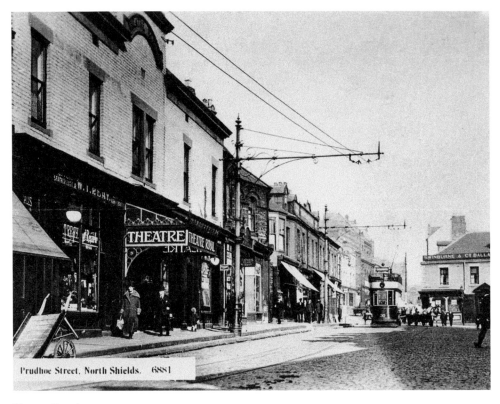

Prudhoe Street, North Shields. 6881

Theatre Royal.

and performing short excerpts of the evening's entertainment as a means of luring the people in. A ploy sophisticated in modern cinemas was the 'coming soon' extracts before the main feature. By 1880 the venue was being billed as Chisholm's New Theatre Royal, although that was not its official name and the performances were more of the music hall variety.

Chisholm tried, unsuccessfully, to sell the theatre in 1881 due to a fall in attendance and in 1882 he transformed it into legitimate theatre. This was successful in drawing the audiences back through its doors. In 1890 Arthur Jefferson Company arrived in North Shields to perform plays written by Jefferson: *The Dawn of Hope* and *The World's Verdict*. Jefferson was the father of Arthur Stanley Jefferson, who would go on to be the world-famous comedy performer better known as Stan Laurel.

In 1894 Jefferson returned to North Shields again and by then he himself managed theatres in and Bishop Auckland. Chisholm retired shortly afterwards and leased the theatre to Arthur Jefferson, who promptly made his family home in Dockwray Square. A blue plaque and statue celebrates his son having lived there.

Jefferson may have overreached himself; he also managed a theatre in Wallsend and took one on in Blyth and several others including another in North Shields – the Boro Circus. He was also to commit to the management of another in Glasgow. His

difficulties really began when his lease on the Theatre Royal expired in 1902 and he was unable to agree terms on the extension of the lease. His response was to put the Boro Circus very much into the public eye; larger adverts and discounted tickets were just part of the campaign to outsell his old theatre. The new manage of the Theatre Royal was Launcelot Snowdon but he died only months later and his role was taken on by his nephews John and Fred Coulson, who had far less experience at running a theatre than Jefferson.

The Boro had recently been rebuilt and renamed the Borough Theatre and had electricity – which the Theatre Royal did not. In addition Jefferson, always a popular local character, was also now a local councillor.

Within two years the new management of the Theatre Royal was in liquidation and Jefferson resumed management once again in late July 1904. Sadly, his financial problems were fast catching up with him. His interests were too diversified and running both the Boro and the Theatre Royal within a short distance of each other had worked against him as audiences were split between the two. The Blyth theatre had always struggled to make a profit. In July 1905 he abandoned his north-east ventures and the family travelled to Glasgow, leaving North Shields behind.

The theatre continued along with management changing regularly, all with varying degrees of success. The cinema business was, however, taking off and while some theatres began providing alternating entertainment between movies and live shows the Theatre Royal as it stood was not sufficiently equipped to do the same. It finally closed its doors for good on 12 March 1932 when it was in fact sold to a cinema proprietor but it never did reopen again as either a cinema or theatre and was demolished in 1939.

Boro Circus/Borough Theatre

The Boro Circus in Lower Rudyard Street had originally been owned and managed by Alvo Thorpe initially as a temporary wooden building. As we have seen above Jefferson took it over after Thorpe died in 1901.

The Borough Theatre was one of the venues that began showing films as well as live entertainment and became known locally as the 'Picture Hall'. The building was ruined by fire in 1910 and reopened in August that year still as both a cinema and variety hall. As a cinema it became part of the Gaumont and later Rank Organisation until 1957 when it was demolished and replaced with shops and housing.

Central Hall of Varieties

Originally this was Oddfellows Hall in Saville Street and stood above the Central Hall public house and a boot shop. In 1899 William Mould leased it and converted it into a music hall, which opened on 20 February 1899. The following year it was destroyed by yet another fire. Temporarily Jefferson allowed Mould to use the Assembly Rooms, which he managed.

Mould had the hall rebuilt and it reopened as the Central Palace of Varieties in late 1901. The theatre began showing films in 1913 and by 1929 was in full-time use as a cinema, continuing in that role until 1958 when it closed and was demolished.

Boro Theatre or Circus.

Princes Theatre

This opened in Russell Street in 1929 as both a cinema and variety theatre but was sold only two years later when it became a cinema exclusively. The building is still in use as a bingo hall.

Theatre still continues in North Shields and Tynemouth and worthy of mention are the Exchange at the foot of Howard Street, a building that functions as a pub, an art exhibition centre, musician's venue and upstairs is a small auditorium.

The Low Lights Tavern on the quayside occasionally hosts short plays in the tiny function room to the left of the main entrance.

Tynemouth Priory Theatre

In addition is the Tynemouth Priory Theatre, which began life in 1946 as the Priory Theatre Club founded by Miss Ria Thompson. Having no base at that time the club utilised the Holy Saviours Church Hall for their performances, which not only involved transporting the scenery on the day of the performance but also incredible amounts of time setting up the seating and the lights.

In 1972 the Old Wesleyan Chapel in Percy Street was purchased – the building was then ninety years old. With renovation and alteration, it became the permanent home of the much-loved Tynemouth Priory Theatre and to this day it remains a club run by volunteers and has charity status.

Wesley Hall. (Courtesy of Ray Lowry of Tynemouth Priory Theatre)

Tynemouth Priory Theatre.